Digital Camcorder

A USER'S GUIDE

Digital Camcorder

A USER'S GUIDE

Peter Wells

THE CROWOOD PRESS

First published in 2006 by
The Crowood Press Ltd
Ramsbury, Marlborough
Wiltshire SN8 2HR

www.crowood.com

British Library Cataloguing-in-Publication Data
A catalogue record for this book is available from the British Library.

ISBN 1 86126 811 4
EAN 978 1 86126 811 2

Designed and edited by Focus Publishing,
11a St Botolph's Road,
Sevenoaks
Kent TN13 3AJ

Printed and bound in Great Britain by Biddles Ltd, King's Lynn

CONTENTS

Acknowledgements . 6

1 Introduction . 7

2 The Kit . 11

3 In Theory . 35

4 In Practice . 55

5 Creative Considerations 70

6 In the Real World . 89

7 What Now? . 122

Glossary . 123

Index . 127

ACKNOWLEDGEMENTS

Writing is a lonely job – one that drives you to invent a lot of imaginary friends. This 'thanks list' is the final step of a long writing process, and I can no longer be sure which of the amazing people who have helped me along the way are real and which just live in my head. Crowood were wonderfully helpful but able to keep their distance when there was little to say. Delivery of this text was substantially delayed – one of the hazards of becoming a full-time dad as well as a freelance video-everything – and yet I was never made to feel harassed, haunted or stalked. You couldn't invent better publishers than that! As always, I'd like to thank Bob Crabtree, former editor of *Computer Video* magazine and now the man behind DVdoctor.net, for kicking me into shape as a writer many years ago (even if I often felt like kicking back). My wife, Margaret has tried to keep me sane through the whole process, and contributed many of the images to the book, in front of and behind the camera – service beyond the call of duty and a nice reassurance that the words I'm turning out might actually make sense to other people. Ray Liffen of Intec Services was a massive help with equipment shots, as well as providing material on performance and wedding shoots for the 'Real World' chapter, and Alan Roberts is a huge inspiration and constant reminder that there is a science behind all of this. My dad, Jack Wells, rustled up a load of storyboards at a moment's notice; Michaela Brown acted as chauffeur, model, photographer and drinking buddy on more than one occasion, and Alex didn't complain when I interrupted his Sunday afternoon pint with an impromptu photo shoot! Sally Moir's help with coverage of children's parties helped illustrate some of the chaos that can ensue; and Mirko, Alex and P.J. Kamann were very patient and willing models, as well as babysitters when things just got too hectic. A big thanks also must go to little Logan for overcoming his camera shyness and being utterly gorgeous. Additional shots were provided by manufacturing companies and distributors, including Sony, JVC, Canon, B. Hague, Steadicam and Warmcards.com. If I've missed anyone, or made anyone up, please find me online at www.pcwells.com and let me know!

1 INTRODUCTION

Techniques of storytelling through moving images have remained largely unchanged since the birth of cinema. Certainly, the introduction of new technology such as sound, lightweight cameras, zoom lenses, tracks, dollies and special effects have greatly increased the film maker's vocabulary, but the core language has survived unscathed for over a century. What has changed, however, is the way in which movies are made – particularly at the lowest end of the economic scale. While big mainstream productions still divide up their workload between many technicians and artists, each with a single specific skill, today's freelancers and small-time independent companies often carry out complex projects with a team of only one or two people. The new generation of videographer must now also be a competent sound recordist, editor, producer and director. And the same is true of the enthusiast – those who make movies for their own enjoyment rather than as commercial products and, thanks to the low cost of digital video technology, find themselves working with many of the same tools as freelance professionals.

In the home, camcorders serve much the same purpose as 8mm cine cameras did in the 1970s and 80s, allowing individuals and families to capture memories as moving images rather than being restricted to still photographs. Cine film still delivers an arguably superior picture quality than standard definition video, but video quickly won out thanks to its relatively low cost and the convenience of being able to screen footage immediately on a TV set without the need for a projector and separate screen! More adventurous movie enthusiasts saw definite advantages in editing, too. With 8mm cine film, the actual original frames needed to be inspected, chopped and taped together to create a sequence. Video editing, from its very earliest days, was developed as a non-destructive process in which footage is copied into a sequence, leaving the original master undamaged.

For the dedicated enthusiast, consumer-level video has always been cheaper than 8mm film – especially when you take into account the price of individual 50ft reels that last only three minutes, and the fact that they can't be erased and reused. But it wasn't until MiniDV made its appearance in 1995 that consumers got anything like the quality they wanted from camcorders. At its best, MiniDV delivered picture quality comparable to some broadcast sources, and its digital nature allowed it to be copied and edited with virtually none of the signal loss that plagued tape-to-tape linear editing over analogue channels.

All this innovation spelled good times and bad for movie production. On the positive side, high quality, low-cost video equipment is

serving to democratize media by putting powerful and persuasive communication tools into the hands of anyone who has something to say. And this isn't just giving a voice to those with enough disposable income to buy their own camcorders and computers: my first real hands-on experience with shooting and editing video came at a community resource centre in Edinburgh, called the Video Access Centre. At that time, they were kitted out with a couple of decent SVHS camcorders and a rather basic linear edit suite, but it was enough to make a movie, and their rental charges were streamed in such a way that even those on very low incomes could afford them if they were keen enough to plan, budget, save and club together for a few weeks. The VAC is still there, and still serving the same purpose, only now it is bigger and better, on new premises, kitted out with some impressive digital kit, and known as Mediabase. It also provides 16mm film gear, too. Community centres like this are to be found around the UK and abroad, if you take the time to look.

Smaller production teams present viewers with a more individualized outlook on the world than you might otherwise get from big-budget projects, and while some can be amateurish and others painfully self indulgent, more than a few become essential, compelling viewing. Classic B-Movie producers, and the exploitation film makers of the 1970s learned first hand that big production budgets can be as debilitating as they are helpful, and these lessons are being learned again by the new generation of digital producers. The more money an investor pumps into a project, the more control they will want to have over it. The kind of budgets required for DV-based movies are insignificant compared with the movie mainstream and, given the right pitch, some investors will willingly take a gamble of a few hundred or even thousand pounds, knowing that if your movie sells they'll make a profit, but if it goes nowhere they'll hardly feel the sting. In this way, working digitally on a tiny scale gives immense freedom and limits the amount of interference you'll encounter from the 'money men'.

On the other hand, without the need to justify every frame, account for every penny and give the hard sell to a specific target demographic, your work runs the risk of becoming unfocused, flabby and self-absorbed. Large- and medium-budget projects are often made with direct investment from a distributor or broadcaster and, as such, the producers know exactly who their movie is being made for and are as certain as anyone can be that their work will be seen. At the micro-budget level, it is often tempting (or just plain necessary) to go into production without those investors and assurances in place – and without secured distribution, movies can sit unwatched for months, or years, or an eternity, as potential buyers decide that they are 'not quite what we're looking for'.

Toward the end of my degree course in film and TV production, digital and cable TV were becoming exciting buzzwords – thought of by many as mythical beasts looming on the horizon that would bring jobs for all and make the world a rosier place. The story went that some 200 channels would appear, all hungry for new, original content. In this brave new world, anyone with something to say and the means to say it would be given a voice and a regular paycheque.

As we now know, that mythical beast turned out to be a big damp squib. Hardly of the new channels were interested in original content, preferring instead to recycle old sitcoms, soaps and even fossilized game shows. While many channels started off with their own presenters and a live studio environment, this approach quickly went by the wayside in favour of totally recorded material, bought in

on the cheap. Among those cable and digital broadcasters that did screen their own material, the standard on offer went no higher than a News Bunny and Topless Darts. Even targeting the lowest common dominator possible failed to draw viewers and advertisers, and the idea of channels providing their own content was quickly drowned, buried and forgotten. A hard lesson seems to have been learned by digital broadcasters in those early years, and that lesson seems to involve steering clear of new material and recycling old rubbish that can wear like comfort blankets.

Immediately after graduation, back when we were all still waiting for digital TV to arrive like a parade of Santas, I was cocky, arrogant and determined to find big mainstream production work. Despite having won a competitive scholarship along the way and weaselled my way into work experience with some well-respected companies, my college showreel and the breadth of my first-hand broadcast experience was much more limited than I realized, and it took many months of fruitless trudging in the real world for the penny to actually drop that I was just microscopic fry in a very big pond.

The big clanger came one afternoon when I'd been going door-to-door around all the post-production companies I could find in London's Soho area, dropping off CVs and VHS showreels, and by this time practically begging for work. As a jack-of-all trades, I approached the industry from a different angle each day, be it as a camera operator, sound recordist, focus puller, boom swinger or tea boy. On this occasion I was an editor. I'd used Avid editing systems at college and thought I'd try selling myself as an Avid operator. Most companies smiled politely, took my tape and paper, and told me they'd put me on file. Across town in Camden, MTV gave me an earful of angry bile for even daring to approach them – a scene that reminded me greatly of the voice of Oz booming from behind a curtain.

One editing company, though, took me aside, sat me down and offered me a cup of tea. I thought my luck might have changed until they also presented me with a massive lever-arch file, stuffed so tightly it would barely close. Flipping through the pages, I saw that it was full of names, telephone numbers and addresses – each one, I was told, belonging to an experienced Avid editor. Non-linear editing was a new phenomenon at the time and there weren't very many Avid systems around, even in Soho. Even leaving that aside, there were far more qualified editors out there than there would ever be jobs for. I was invited to add my name to the book, but advised not to wait in for a phone call.

Over the last decade, even more people have had the chance to work with high-quality, well-featured video gear, thanks to ever diminishing hardware and software prices. And the proportion of keen workers to available jobs in the mainstream broadcast sector has rocketed even further to a point where many media graduates have chosen to retrain as plumbers and electricians, realizing that the smart move (if you want to earn a secure living) is to learn a trade for which there's actually a demand for workers.

But while conventional routes into professional video work have become slow and congested, those wannabes with their eyes open will realize quite quickly that technological developments in the affordable video market have changed the whole landscape from top to bottom. It is easier than ever to step off the beaten track and ramble off on your own. You might end up completely lost, but if all goes well you'll probably be too busy to notice.

Along with affordability and accessibility of production equipment, the growing under-belly of DIY moviemakers is establishing its own means of distribution and exposure. Ten

years ago, options were limited to private screenings and film festivals. Today, increased uptake of broadband internet access means that web streaming is a real and sensible option for reaching audiences worldwide. For small video labels, the cost of DVD authoring and pressing is quite minimal, provided that you are sure that your discs will sell. I make live music DVDs that sell in shops all over the world. Other producers I know do a very similar job feeding the interests of audiences with a love for classic planes trains and automobiles. We're enthusiasts, guns for hire and very busy freelancers. We're still very small fish, but we've chosen much cosier ponds in which to live. And they suit us fine.

This book is written for the lo-fi video maker, regardless of whether you're a hobbyist making movies for yourself and documenting the lives of your family and friends, or the budding enthusiast keen to grow a hobby into something more closely resembling a paying job. Those of us working beneath the radar of the commercial mainstream will find ourselves using equipment and resources that the big facilities houses often shy away from, but which are capable of delivering first-rate, polished results. Crucial to any work you undertake, however, is good source footage. Creative editing can help you only up to a certain point if you haven't been careful and thorough in your shooting and sound recording.

The following pages explore the world of consumer and prosumer-level camcorders and introduce methods and techniques for acquiring interesting, controlled images, as well as for identifying which environments and circumstances require different approaches to your videography. While reading and experimenting, though, it is essential to remember that any movie is only as good as the ideas behind it. Please take the time to think before you shoot. This book will give you a basic understanding of the vocabulary and grammar of video, but you can only put it to use if you know what it is you want to say.

Recording, editing and publishing digital movies, documentaries and other films is a vast subject: too vast to sensibly fit in its entirety into a book of this length. Good video production must always begin with useful, well-shot footage, and so it is with no apologies that this book concentrates exclusively on the process of shooting, covering equipment and techniques needed to acquire professional-looking digital video. Chapter 2 looks in detail at the equipment that you will need, both the actual cameras and accessories such as microphones and tripods. Chapter 3 covers the theory of using the equipment, getting used to it and dealing with the strengths and weaknesses of different types of equipment. Chapter 4 describes the practicalities of taking different types of shot, recording sound and dealing with lighting. Chapter 5 expands on this, showing how to make the creative most of your camcorder. Finally, Chapter 6 puts all that has gone before into the context of the types of projects you may be working on, from corporate productions and movies to wedding and holiday videos.

2 THE KIT

I spend a lot of time helping people get started with digital video, either face to face at related shows and trade fairs or at a distance via email. Some just want to make home videos for their own enjoyment, while others have bigger plans and business ventures in mind. Those that are completely new to video production are easy to spot – they're the ones whose first question is always 'what should I buy?' And they're invariably shocked when the reply comes, 'what do you want to do?' There isn't a single camcorder or editing solution that's perfect for everyone. The right kit for you depends entirely on the kind of work you'll be doing and the way in which you plan to do it. Think of it like buying a car – you wouldn't recommend a two-seater convertible to a young family of seven in the Lake District. Like any complex tool, each camcorder has its own strengths and weaknesses, and it is essential that you identify the features that best meet your particular needs.

Having a clear idea of the kind of movies you want to make (and the people for whom you'll be making them) is essential before spending any money on video equipment, and that's something you can't get from a book – it is entirely up to you. What's also important is to have an idea of what digital video is all about. It is not necessary at this level to go deep into the guts of the technology or the theory behind it, but simply having a rough idea of what all those fancy terms mean and what different camcorder features actually do will make the buying process a much easier one.

WHAT IS VIDEO?

The word 'video' doesn't exclusively refer to VHS tape. Unlike film or flip-books, which store each frame of motion as an actual image, video breaks that image down into an electronic signal and stores it as code for retrieval on a specialized monitor, such as a TV set. Video is a word used to describe any form of moving image that's stored electronically. Many people associate the word with footage recorded onto magnetic tape, whose content is viewed on a TV set via a special machine. But tape is only a small part of the story – in fact, its days are numbered. Sales figures for mainstream movies on DVD now greatly outnumber VHS, and even the recording of TV shows is increasingly being done to hard drives or recordable discs rather than tape. TV isn't a necessary part of the equation either. The internet is full of movie clips designed to be watched on computer monitors, many portable DVD players come with built-in LCD displays, and videos made for corporate presentation are often presented on traditional movie screens by way of a video projector.

Video Standards

You have to be careful when buying VHS tapes from abroad, as Europe, Australia and New Zealand use a different video standard to America, Canada and Japan. What still seems to surprise people is that these same differences apply to digital formats such as MiniDV and DVD Video. The problem isn't in the formats themselves, rather in the TV sets used in each region. The display frequency of TV sets for any specific country is determined by the frequency of the power supply. The UK's power grid runs at 50Hz while the USA's runs at 60Hz (technically 59.94Hz). The result is two different video standards – PAL, which runs at 25fps (frames per second) on 50Hz displays, and NTSC, running at 30fps (technically 29.97) on 60Hz screens. Differences also exist in image size in the digital domain. As NTSC has a higher frame rate, it compensates with a smaller frame size: NTSC DV video has a frame size of 720×480 pixels as opposed to PAL's larger resolution of 720×576.

WHY DIGITAL?

'Analogue' and 'digital' terms come into play when media is stored, moved and copied. In analogue recording, sound and light are captured as actual sound and light waves and recorded directly to tape in a wave format, having been converted to magnetic fluctuations on tape, which can be converted back to a sound or picture on playback. Digital recording is different. Rather than attempt to simply capture the wave signal of light or sound, a digital recording will break the information down into 'samples', creating an approximation of the original that can be read and copied numerically.

While analogue recording is the simplest method of reproducing and storing video

and audio, the machinery and tapes required to do a good job are very expensive. Audio cassettes of the type used in mainstream stereo systems and personal stereos are prone to mechanical 'hiss', and aren't capable of reproducing the original wave accurately enough to give great depth or vibrancy. Similarly, VHS video recorders are typically only able to reproduce around 250 lines of video image, despite the fact that the original broadcast signal had double that resolution. More effective analogue equipment does exist in the broadcast and professional recording industry, but is so outrageously expensive that it will never make an appearance in the home market. Digital audio and video recording methods have filled that gap, providing a means of delivering high-quality picture and sound for very little money. They are not without their limitations and compromises, though!

There is a common misconception in the consumer electronics marketplace that anything analogue is bad and all things digital are good. That's not necessarily true. All music enthusiasts have, at one time or another, been involved in heated arguments over the pros and cons of vinyl records (an analogue format) versus CD (digital), and while it is generally agreed among those that care that vinyl delivers superior sound quality, the digital format still wins the day thanks to its size, cost and convenience. The same thinking applies to almost all forms of digital media. Digital doesn't necessarily mean better quality – it just makes good quality cheaper, and playback more convenient.

Analogue video signals are prone to 'generation loss': their signals degrade slightly when passed through a wire to a TV set or another video recorder. Duplicating an analogue tape will result in an inferior copy, and if copies are made from copies, each

successive generation of video will look worse than the last. By contrast, copying digital video via digital channels such as FireWire will, in theory, result in a clone of the original. The process can fall foul of tape manufacturing faults or poor error correction during the duplication process, but in the textbook scenario, a digital copy simply replicates all the ones and zeros that make up the original video data, yielding a perfect clone. In the real world, making successive copies of copies will probably give rise to noticeable errors after six or seven generations, but it is the supposed 'lossless' nature of digital transfer that made the consumer DV format so exciting and helped turn video editing into a mainstream pastime.

The quality and accessibility of digital media depends on compression. This is covered in more detail below, but in simple terms the compression process is used to reduce the size of horrendously big data files, making them easier to store and manage. In 1995, Sony launched the MiniDV video format for 'prosumer' camcorders, which soon filtered down to the entry level, putting near-broadcast quality video in the hands of practically anyone.

But it is important to remember that this consumer market has always been driven by cost and convenience rather than by quality. Take, for example, the case of DVD Audio which, its developers insisted, would finally replace CD as the standard mainstream music format. DVD Audio is very impressive, providing 24-bit surround sound at 96kHz – a resolution of digital audio that could actually stand up well against vinyl. Lovely as the format may be, it is one in which the general public seems to have precious little interest. Perhaps it is because CD is considered 'good enough' for the mainstream. Or maybe people aren't equipped with (or bothered about) the high-end speaker systems and amplifiers required to appreciate DVD Audio at its best. It is also worth noting that, by the time DVD Audio appeared on the scene, MP3 had already revolutionized the way in which music is stored, played and shared online. The possibility of downloading tunes from the internet for playback on tiny trinkets appears to be a far more attractive idea than the subtly superior sound quality offered by DVD audio.

A similar example can be seen with Laserdisc in the 1980s – movies were stored on 12in discs, looking like silver LP records. Movie quality was far superior to that of VHS, but discs had to be flipped halfway through a feature film, Laserdisc players were expensive, and the format itself wasn't a recordable one. So the mainstream stuck with inferior, analogue VHS tapes. There are plenty of failed format stories out there if you want to dig deep enough – and in far too many cases their moral seems to be that quality alone isn't enough.

COMPRESSION

Video is extremely data-heavy, and the higher the video quality, the more information it will contain. This was as much an issue in the analogue age as it is with digital formats – video channels such as S-video and 'component' are all developed to divide video signals into separate parts and move as much video information over a single cable as possible (but the fine detail of that is a matter for another book!). In the digital world, the problem is twofold – video tapes and computer hard drives need to be able to accommodate large video files, and players and editing systems must be able to move this information quickly so as to play and copy footage in real time. In the early days of computer-based video editing, high-quality video files were far too big to be managed by affordable computers. Even now, the average desktop

computer would struggle with uncompressed video files at broadcast resolution. Unlike analogue video formats, digital video data needed to be compressed into smaller, more streamlined chunks.

Compression reduces the overall file size of video, making it easier to store; and the amount of data being read per second during playback is reduced, making it easier to manage on affordable computer equipment. Unfortunately, digital information can't just be shrunk to fit a convenient space. The only way to make a data file smaller is to throw some of its information away. There are many different types of compression technique, but they generally work by identifying the information they plan to discard and creating an index so it can be recreated and replaced at the playback stage. A good analogy is the way in which estate agents will use shorthand terms such as 'GCH' for 'Gas Central Heating' in order to cram as much information as possible into a small advert. The reader is conditioned to understand what 'GCH' means and will fill in the missing detail. In a similar

manner, video compression can only be successful if the player understands where and how to replace discarded information. The overall process requires a compressor to squeeze the file and a decompressor to make sense of it again. Compression tools are often referred to as Codecs, being a hybrid of these two words.

Codecs tend to focus on one of two aspects of video material – colour and detail. Digital video has a component colour space, known as YUV, where Y is luminance or brightness, and U and V are colour channels ('U' is red minus Y, and 'V' is blue minus Y). Very high-end broadcast video formats have a 4:2:2 colour sampling method, sampling four 'Y' luminance pixels for every two 'U' and 'V' colour pixels. The result is first-rate colour reproduction, but large file sizes.

More inexpensive digital video formats such as MiniDV compromise on the colour sampling. PAL DV footage has a sampling method of 4:2:0, and NTSC DV uses 4:1:1. Colour bandwidth is greatly reduced in each case, and while this has little direct effect on

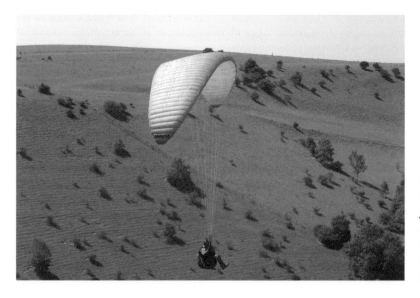

In this shot, the active part of the frame around the paraglider will be updated, while the static background is left unchanged.

straightforward video editing, it can create headaches when it comes to special effects. Chromakey effects in particular – replacing blue or green backgrounds with other footage – can suffer from very noticeable fringing around the borders of objects. Seamless compositing effects with compressed DV footage are tricky, and many movie makers opt to convert their DV footage into uncompressed files for this sort of work. Publishing on DVD, in multimedia presentations or streaming on the internet, requires video to be compressed even further, requiring even more compromises, such as dismantling of the frames themselves. While PAL DV video is composed of fifty interlaced fields, giving twenty-five individual frames, MPEG files made for DVD have far fewer complete frames (on average one every one and a half seconds), while only parts of the frames in between are updated. In the shot opposite, the area of the frame with a moving object is updated, while the static background isn't.

What results is a GOP (Group Of Pictures) structure, consisting of the complete 'I' (intra) frame, 'P' (predicted) frames, which are derived from previous reference frames using motion vectors, and 'B' (bidirectional) frames, which are generated from elements of previous and future frames. Done well, MPEG footage can look stunning, but the frame structure doesn't lend itself well to frame-accurate editing, as every cut may require new 'I' frames to be created from 'B' or 'P' frames. The regular decompression and recompression of footage can lose a lot of detail and is nowhere near as elegant as DV editing. For that reason, MPEG is largely reserved for publishing completed movies, and is seldom used as an acquisition or editing format. There are exceptions, however, as we shall soon see.

This sleek CD walkman will also play VideoCD discs.

DIGITAL VIDEO FORMATS

Until the mid-1990s, video in the home meant VHS – for most of us, anyway. Digital media was tested in the consumer arena as far back as the early 1980s, though, most notably in the form of Laserdisc. The fact that they weren't recordable, and had to be flipped half way through a feature film, resulted in the format being restricted to use only by the most fanatical movie buffs, regardless of the fact that picture and sound quality was so much better than that of VHS.

The Far East had a much more successful digital video format, however. VideoCD (VCD) was, as its name suggests, video distributed on compact discs. Quality rarely surpassed that of VHS, and each CD could only accommodate around 60–70 minutes of video, meaning that feature films had to be spread over two discs, but VCD was massively popular in China, Hong Kong and elsewhere. A staggering assortment of combi-players were developed to play video and audio CDs in one unit. Special add-on modifications also appeared for games consoles such as the Sony Playstation to allow them to play VCDs, and it was briefly adopted by video enthusiasts in the UK, Europe and North America while they waited for sensibly priced DVD recorders to appear on the scene.

15

Smaller analogue video cassettes helped introduce miniaturization to the camcorder market.

The kick-start needed in shaping digital video formats for home camcorder enthusiasts owes much to the limitations of analogue video. While there was always a hardcore demand for camcorders that used full-size VHS tapes, many home users considered such machines to be too large and cumbersome to accompany them on holidays and other family occasions. The need to make the machinery more compact gave rise to smaller tape formats such as compact VHS (VHS-C) and Video8. A growing interest in trimming unwanted footage, editing sequences and even adding titles sparked interest in higher-quality video formats. Before computers came into their own for video editing, cutting was done by copying footage from one tape to another. Starting off with a quality of picture and sound that greatly surpassed the capabilities of VHS would help compensate for any generation losses that happened along the way, and help users achieve a crisp, clean edit for sharing with friends and family.

High-quality analogue formats such as SVHS and Hi8 did good business for a while, but things were completely turned on their heads in 1995 with launch of MiniDV. The DV format put much higher quality video into the hands of home users. Its picture quality was only slightly below the quality of the broadcast standard of the time, Beta SP, and, at the time of writing, it is still going strong as the single mainstream camcorder standard, only now being threatened at the high end of the market

by a newly developed high-definition format, HDV (of which more later).

Different digital video formats exist for different purposes. There are acquisition formats for camcorders, file formats exclusively for editing, and delivery-only formats for distribution. From time to time, companies try to mix them up with products such as DVD-based camcorders and cameras that record video for the web, but the strategy rarely seems to fully take off.

ACQUISITION FORMATS

DV, MiniDV, DVCAM and Digital8

MiniDV was the first digital camcorder format to break into the consumer mainstream. Sony launched it in 1995 with the now legendary VX1000 camcorder, a relatively small machine for the time that captured the imagination of many broadcasters and independent professionals. In the following decade, MiniDV became the accepted standard for budget-conscious professionals as well as occasional home users. At the time of writing, MiniDV format camcorders range in price from £200 to £3,500.

Along with MiniDV, Sony also launched a larger cassette format called DV, a 'pro' equivalent called DVCAM, and a budget version known as Digital8. Large-format DV tapes are essentially the same as MiniDV, but housed in a bigger cassette to accommodate running times of over four hours. They are

supported by a small handful of shoulder-mounted professional camcorders and by digital video recorders used in edit suites.

Despite being presented as a 'pro' version of DV, DVCAM equipment records video in exactly the same digital format as MiniDV. The difference comes in tape speed – a 60-minute MiniDV tape would only accommodate 45 minutes of DVCAM data. The faster scanning speeds allow data to be recorded to a larger area of tape, helping avoid problems that can be caused by poorly manufactured tape. The appeal of DVCAM, therefore, is to better protect footage for professional projects that possibly cost a lot to set up and shoot.

On the other side of the budget scale, Digital8 was developed in the early days of DV to allow camcorder manufacturers to make low-cost digital camcorders using many of the parts that have already been mass-produced for Hi8 models. Digital8 records the same type of signal as MiniDV and DVCAM, but records it to a Hi8 tape. The camcorders are bulkier than their MiniDV counterparts but they were considerably cheaper for many years. Recently, however, Hi8 and Video8 camcorders have been phased out of the marketplace, and MiniDV production costs have fallen to a point where it no longer makes financial sense to use Hi8 parts. While MiniDV has been adopted by all mainstream camcorder manufacturers, DVCAM and Digital8 remain largely exclusive to Sony.

DV video has a frame size of 720 × 576 pixels for PAL footage and 720 × 480 for NTSC video – and that's regardless of whether material is being shot fullscreen for 4:3 TV sets or widescreen for 16:9 displays. As we'll see in the next chapter, video footage is horizontally stretched to achieve the desired shape. DV is normally interlaced, with each frame being composed of two interleaved 'fields'. PAL footage runs at 25fps and NTSC has a frame rate of 29.97fps. Some high-end DV camcorders also allow progressive-scan shooting at 24fps – more on that later. DV compression keeps frames intact, choosing to compromise colour instead. The result is

ABOVE: An inexpensive MiniDV camcorder for home use.

RIGHT: A very high-end MiniDV model for budget-conscious professionals and well-heeled enthusiasts.

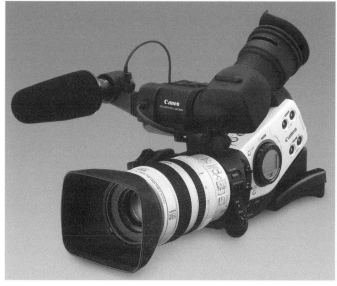

a data stream five times smaller than uncompressed video at the same resolution and frame rate.

MicroMV

MicroMV is another Sony creation, designed to make consumer camcorders even smaller than they had already become. Tapes are less than half the size of MiniDV cassettes, and the resulting camcorders are easily slipped into a pocket and carried anywhere. As with Digital8 and DVCAM, however, MicroMV was never adopted by any manufacturer other than Sony, and failed to make a noticeable splash in the marketplace. As a result, support for the format in mainstream video editing software was limited. Another hindrance may be the fact that MiniDV models were already very small and cute to the point where any further reductions would mean the loss of even more buttons and physical controls. At the time of writing, Sony has decided not to further extend its line of MicoMV camcorders.

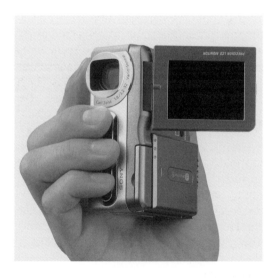

The small size of MicroMV tapes allowed the camcorders themselves to be truly tiny.

MicroMV records at the same resolution and frame rate as DV, but at half the data rate – 12Mbit/s as opposed to DV's 25Mbit/s. The increased compression is achieved though a form of MPEG-2 compression that uses an IPB frame structure to lose 'unwanted' detail from frames. This method of compression is considered fine for delivery formats such as DVD, but it presents very real hurdles when it comes to editing. Enthusiasts didn't consider the compromise a worthwhile one, when DV was already doing such a great job, and the absolute novices were drawn more to the low price of MiniDV camcorders than to the small size of MicroMV.

DVD-R and DVD-RAM

DVD has taken the home cinema market by storm, and the idea of shooting directly to a little shiny disc is bound to be an exciting one. DVD-based camcorders are easily found in electronics shops, but they're to be treated with caution if you have serious plans for your video. As with MicroMV, DVD Video uses an IPB-frame MPEG compression format, which efficiently reduces the size of video data, but can cause problems when it comes to video editing. It is frame rate and resolution are also the same as DV, making the trade-off for DVD somewhat less attractive.

More problems arise with the type of media used. The first DVD-based camcorders used DVD-RAM media, which can't be played on the majority of household DVD players. In order to share video with friends and family, it would have to be copied onto a DVD-R or DVD+R disc, largely defeating the purpose of shooting directly onto disc in the first place. DVD-R camcorders eventually appeared, but these too had their limitations – in order to keep camcorder sizes small, they use little 8cm DVD-R discs. Not only are these hard to find (in computer shops let alone tourist souvenir shops!), but their recording time is limited to

thirty or sixty minutes, depending on the quality setting you choose. Note too that DVD-R is a write-once format, and can't be erased or reused in the same way as DV tape. The appeal of a DVD-R camcorder is obvious though, in that it allows users to immediately play their recordings using a DVD player – great for those with no great interest in editing video, but for the rest of us, it is a considerable step back from the versatility of MiniDV.

HDV

HDV is one area where people have been willing to accept more aggressive MPEG-2 compression in a new format. There are currently two different HDV standards available to prosumers, but both offer the same benefit over ordinary DV: a higher-resolution picture. JVC was first out with an affordable HDV camcorder, offering a progressive scan image with a resolution of $1,280 \times 720$ pixels, and this was closely followed by Sony's version of HDV, with an interlaced picture measuring $1,440 \times 1,080$ – roughly four times the area of standard DV!

High definition broadcast and video signals offer a visual resolution between two to four times greater than the standard-definition signals that dominate mainstream broadcast and DVD distribution at the time of writing. The importance of high-definition video might not be immediately obvious, as high-definition broadcast has yet to be properly rolled out in the UK and mainland Europe. But HD TV is coming, and many video makers are keen to ensure that their work is as future-proof as possible. What's more, there's also a growing market of LCD and plasma-screen TV sets, capable of displaying a much higher resolution picture than traditional CRT sets. A final consideration is the ever-growing number of would-be film makers who can't afford the prohibitive costs of shooting on film. While many film festivals now

DVD discs are now being marketed to camcorder users – but DVD-based camcorders are still something of a novelty item.

accept entries on video, standard definition DV always looks poor when fed through a video projector in a cinema. HDV increases the picture detail and makes for a more impressive presentation.

Regardless of which type of HDV format you look at, both are recorded in MPEG-2 format, at the same data rate as standard-definition DV video. What's more, HDV video is recorded to ordinary MiniDV cassettes, and camcorders can be switched to record in either high definition HDV mode or standard DV, depending on what the job (or the client) requires. The formats are very new, however, and while they're quickly being adopted and supported by video-editing programmes at the prosumer level, it will be a while before HDV editing systems are really mature, and the camcorders themselves are still restricted to the highest price brackets. Still, anyone making money from video can't afford to overlook HDV.

Media-free

Another very recent development in the camcorder market is media-free recording.

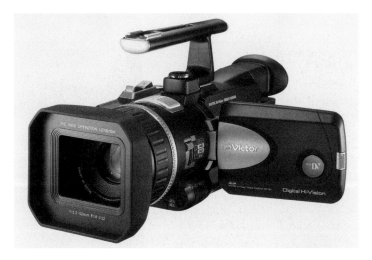

JVC's first HDV camcorder, the GR-PD1.

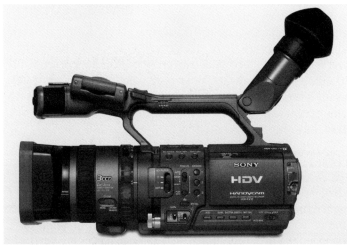

LEFT: *Sony's first HDV model, the HDR-FX1.*

ABOVE AND RIGHT: *Comparative sizes of a standard-definition DV video frame and a 1080i HDV video frame.*

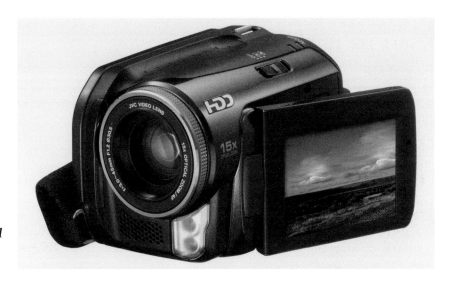

JVC's first hard drive-based camcorder.

Just as audio enthusiasts have a choice of numerous hard-drive-based sound recorders, so the same philosophy of tape-free or disc-free recording is reaching the video world. One of the very first companies to introduce hard-drive camcorders into the consumer marketplace was JVC. Its first model uses MPEG-2 compression to keep video file sizes small, and image resolution is standard definition – no greater than you'll get from MiniDV or a DVD-based model.

Video might be compressed more than I'd like for this stage of the movie-making process, but it does allow many hours of footage to be stored on the camcorder's internal hard drive, allowing continuous shooting of long events without having to swap tapes half-way through, and should allow home users to get through holidays and family events without having to worry about having enough blank media to hand. The disadvantage, however, is that users need to be disciplined enough to back-up and wipe the drive at regular intervals to ensure it doesn't get full at inopportune moments.

Oddities

There's now a staggering number of devices that will record 'digital video'. Some budget electronics retailers sell insanely cheap cameras capable of recording video to internal memory chips. Digital still cameras are often blessed with the ability to record video, too. And even the latest generation of mobile phones allow video recording and video messaging. To date, none of these devices give good enough quality to compete with even the most inexpensive MiniDV camcorder. Video recordings are normally made to a low resolution and a frame rate of fifteen or twelve frames per second. They're fine for emailing to friends and family, but they're not intended for viewing on a TV or editing into a high-quality production. If a device doesn't record one of the recognized digital video standard listed above, be very wary. It might be great for point-and-shoot operation and the immediate sharing of moments, but its creative application is likely to be limited.

CAMCORDERS EXPOSED – UNDER THE HOOD

Basic Shape

Most camcorders fall into two style categories – the upright camcorder and the palmcorder. Upright models are tall and thin, with a lens and viewfinder at the top, and a chassis that users grasp like a pistol grip. This style was once common with 8mm cine cameras, and while many people find them awkward, design has come on by leaps and bounds in recent years, ensuring that controls fall easily to hand. The upright design is restricted to the consumer mainstream, however – you won't find any such models with 'pro' leanings. They're designed to be portable and convenient, and are often the smallest models available, but this brings with it the compromise of having smaller LCD panels and fixed viewfinders that can't be moved.

Palmcorders are more tubular, with a lens at the front and viewfinder at the back. The design is a scaled-down version of large-format camcorders, but with the shoulder rest removed, and this has been the classic look since models became small enough to be hand-held. The palmcorder shape allows for a larger LCD screen (although many are still rather mean in that department) and they often have viewfinders that can be angled upwards for low-angle shooting. Common opinion among enthusiasts are that palmcorders are the most comfortable of the two designs to use, but both have their good and bad points.

From time to time, camcorder manufacturers will deviate from these two styles. Some modern DVD-based models, for example, place the disc compartment along the back of the machine rather than at the side, resulting in a camcorder that looks like a cross between a personal CD player and a digital stills camera. Some MicroMV models became so small that they offered users a fold-down grip handle, rather than simply adding a hand strap to the main chassis.

The CCD

A camcorder's charge coupled device (CCD) is a chip that serves much the same function as the retina of the eye. It processes incoming light and produces an electronic signal for use by the camcorder. CCDs are composed of pixels, each one acting like a mosaic tile, providing a block of colour to the overall image. Unlike digital stills cameras, the number of pixels in a camcorder's CCD has limited bearing on the resolution of the video it records. Resolution is tied to the video format – so DV footage will have a maximum possible frame size of 720×576 pixels (720×480 if you're shooting NTSC) regardless of whether the camcorder's CCD has 40,000 or 3 million pixels. Some high-end DV camcorders have CCDs with a resolution of only 320,000 pixels, but are still capable of producing stunning, well-defined video images.

The megapixel CCD was initially introduced to camcorders to capture high-resolution stills to memory card, allowing users to record photos and video with a single device. Having more pixels than the video image needs can also be useful in providing high-quality digital image stabilization and, more recently, improved 16:9 widescreen shooting. Electronic image stabilizers work by cropping into the resolved image (i.e. the picture after it has been processed by a camcorder's CCDs and converted to a matrix of pixels), using the border to compensate for camera shake. In early models, this meant compromising on picture quality, but megapixel camcorders can now process a much larger area than is needed for DV, providing a safe area for stabilization without affecting the quality of the visible picture. Similarly, DV camcorders typically use less of the CCD to process a frame in 16:9 mode than they do for 4:3 fullscreen shots. And

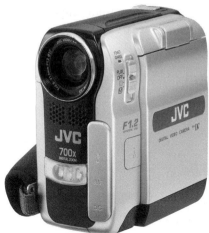

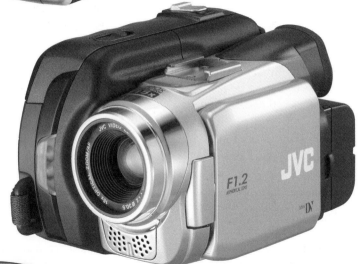

ABOVE: **An upright-style camcorder.**

RIGHT: **A palmcorder.**

BELOW: **This DVD camcorder from Sony falls into neither category.**

while many megapixel models still compromise quality in this way, there are some that use the chip's larger capacity to produce better widescreen footage.

The physical size of the CCD is also important to many movie makers. CCDs in professional broadcast cameras are typically three or even six times bigger than those of domestic and prosumer models. Perhaps most important is the fact that as pixel density increases, its light sensitivity decreases. So the ⅙in, 2.1-megapixel CCDs now found in some domestic models may have poorer low-light capabilities than one with a larger physical size or lower resolution. The change in performance isn't as obvious as you might at first suspect, as the technology behind camcorder CCDs improves all the time, but it is easy to see why some top-end prosumer

models sport ⅙in chips with as few as 320,000 pixels. Broadcast camcorders with 1in CCDs deliver superb footage in low light, and the larger physical area of the CCD can also have the advantage of decreasing depth of field (the range of distance in which objects are in focus), helping create more dramatic shots and enabling a level of versatility to visual storytelling that wouldn't be available with small, ⅙in CCDs.

As well as the size and resolution of CCDs, the number of chips is also an important consideration. Professional and prosumer models almost always have three CCDs rather than just one. In a 3CCD camcorder, a glass prism is used to split incoming light into its primary colours, so each can be processed independently. The result is excellent colour reproduction, and this is particularly

CMOS

Along with the birth of HDV comes some experimentation in the types of light-sensitive chips used in camcorders. JVC's first HDV camcorder, the GR-PD1, has a CCD with a new way of filtering light – JVC calls it a Hybrid Complementary-Primary Digital Filter, which processes two complementary colours (yellow and cyan) along with one primary (green). There are four colour pixels working alongside every pair of luminance pixels, and JVC claims that the CCD produces results comparable to those of a 3CCD array.

In the meantime, Sony's first single-chip HDV model features a complementary metal oxide semiconductor (CMOS), as is often used in digital stills photography. Unlike a CCD, which offloads much of its work to circuit boards within the camcorder, CMOS chips process light for each pixel on the chip itself. With CMOS chips, light values on each pixel

are read immediately, rather than being transported off the chip first, making it a quicker solution for reading an image. Sony's arguments for using a CMOS chip go further still with the claims that CMOS sensors help reduce glare and smear effects, and produce high-impact colour reproduction without the need for three chips. It is also argued the CMOS require less power than CCDs, meaning batteries can be made smaller and last longer.

There are widely differing opinions among experts as to whether CCD or CMOS chips are better for digital photography – and it is worth remembering that almost all digital video cameras from beginner to professional levels use CCD sensors to collect light. CMOS is a new development for camcorders, however, so keep an eye out to see how the early adopters are getting along with them!

noticeable over single CCD models when shooting in dimly lit conditions. Not all CCD arrays process colours in the same way, however, and the last few years have seen endless subjective discussions about the images produced by different camcorders – in particular, pitching Sony's flagship models (which produce a cool and natural tone) against Canon's (whose footage is typically more vibrant and highly saturated).

Lens

Professional movie makers argue that the most important thing about any camcorder is the lens – and it is the lens that makes the biggest difference between true professional and consumer models. A good professional video lens costs more than the average DV camcorder and is optically perfect, giving beautifully well-defined images with virtually no distortion. Companies such as Sony and Panasonic are keen to tout the quality of their camcorder optics by commissioning 'designer' names such as Carl Zeiss or Leica Dicomar, but they are still a long way off from the precision and control of their professional counterparts. Only a couple of camcorders in the higher price bracket will allow you to remove the supplied lens and replace it with something more up-market. All other 'affordable' prosumer and consumer models have fixed lenses that can't be changed. Needless to say, the more you spend on a camcorder, the better its optics are likely to be, but in the absence of choice over optical perfection, there are several lens-related features you can bear in mind as you choose the right camcorder for you, particularly the zoom range and image stabilization.

Optical and Digital Zooms

Most camcorders have two types of zoom: optical and digital. The optical zoom magnifies light within the lens before it reaches the CCD, allowing its maximum resolution to be used in processing the image. Optical zooms work by moving glass elements within the lens barrel, and while they're often far more powerful than zooms on digital stills cameras, they can still be very limited. The minimum optical zoom range you're likely to encounter on a camcorder is 10× magnification, while a small few models sport zooms of 20× or more. Excessive zooms can be difficult to handle, as they exaggerate camera movement, but they can also be invaluable in catching fine detail from a distance or crushing depth of field within a frame for dramatic effect.

Digital zooms, on the other hand, magnify the image after it has been processed. The result is essentially a magnification of the pixels. Taking the mosaic analogy, digital zoom doesn't add detail, it just makes the individual tiles look bigger. The result is a soft and blocky image. Some consumer camcorders might boast digital zooms of up to 500×, but most serious video makers disable their digital zooms straight away. Camcorders at the top of the prosumer range often have no digital zoom at all.

Image Stabilization

Large, shoulder-mounted camcorders for broadcast are well supported by the operator's body and have a lot of weight to help keep them steady and avoid shake. MiniDV and other lightweight formats have given rise to smaller machinery which can need a little help in keeping the picture steady. As with zooms, image stabilizers come in two flavours – optical and digital.

Top-end DV camcorders have optical image stabilizers within the lens, which compensate for camera shake before light reaches the CCD, ensuring that video quality isn't compromised. Results are normally excellent, and most high-end users would be very reluctant to buy a camcorder without optical image stabilization.

LCD viewscreens are a blessing for shooting in awkward angles but can be difficult to use under strong sunlight.

The technology takes up physical space in the lens barrel, however, affecting the overall size of the camcorder. Also, very few companies actually make optical image stabilizers – they're normally associated with Canon and Sony. The licensing involved incurs further manufacturing costs for companies that need to buy them in.

The alternative is electronic or digital image stabilization. Electronic methods have the advantage of saving space and money, as all the work is done within the camcorder's electronics. There's a compromise involved, though, as electronic image stabilizers crop into the processed image, using a border as a safe zone to compensate for camera shake. Some work better than others, but the bottom line is that a large amount of imaged processed by the CCD is being thrown away before it makes it to tape. Large capacity CCDs, pitched at users who want their camcorders to double as digital stills cameras, provide a definite advantage, however. They process more picture information than is required for the video image, allowing an image stabilization border that doesn't rob the visible picture of definition.

LCD Viewscreen

A camcorder's LCD panel was once regarded as a luxury or even a gimmick, but users at all levels have learned to appreciate it as a useful and practical shooting tool. As well as providing a decent-sized view of the video being recorded to tape, LCD panels allow users to pull the camcorder away from their faces and use them in positions and at angles that wouldn't be possible if they were tied to the viewfinder. A good LCD screen 3in (8cm) or more wide can be a great blessing – particularly when working at difficult high or low angles – but strong sunlight can make them difficult to see properly. Specialist retailers can provide a hood that will give much-needed shade.

Viewfinder

The camcorder's viewfinder is often an overlooked feature when buying a camcorder, but it can save your skin – particularly when shooting in strong sunlight that makes the LCD panel hard to see. The cheapest entry-level camcorders offer only a black and white viewfinder, expecting that most users will be using the LCD panel anyway. As prices

increase, so does the quality of the viewfinder, quickly becoming colour rather than black and white, and gradually being made physically larger and with a higher resolution. At the time of writing, Canon's flagship MiniDV camcorder, the XL2, sports a 2in (5cm) viewfinder that can also double as an LCD panel. Oddly, at the very highest levels, camcorder viewfinders become black and white again – but this time with a much higher resolution than was previously available in colour. Many professional users prefer monochrome viewfinders anyway, as they provide a much clearer representation of focus and exposure.

Shoes

A shoe is a means by which accessories are mounted onto a camcorder. SLR cameras use shoes for mounting flashes, while camcorders provide them for video lights, microphones and even external recording devices. Shoes can be powered, allowing the camcorder to provide electricity and instruction to compatible accessories or unpowered, in which the device will have to find power itself. To make use of a powered shoe connection you may need to buy specific accessories from the camcorder's manufacturer. It is also likely that they'll drain the camcorder's battery very quickly. Working unpowered gives you a wider choice of devices, but also leaves you with more batteries and power supplies to worry about.

Microphone

Camcorders' built-in microphones tend to have little directionality. This, coupled with the fact that they're normally kept far away from the subject gives rise to some very weak sound recording. If you're prone to talking to the camera while shooting, your voice will be sparkling clear, while everyone else will sound distant and muffled. Investing in a good external microphone is essential for serious work. More about that later.

Sockets

Digital and analogue audio and video sockets are necessary for watching footage from the

ABOVE: *A camcorder's shoe attachment.*

RIGHT: *An external zoom, focus and start/stop control made by Manfrotto.*

camcorder, recording it to other tape formats or transferring it to a computer for editing. In DV and HDV camcorders, digital video (and its soundtrack) are served via a FireWire socket (also known as i.Link and IEEE1394). FireWire sockets come in two sizes: camcorders have small four-pin sockets, while many computers feature larger six-pin ports. The larger sockets allow the host computer to provide power to FireWire peripherals such as external hard drives. The power channels aren't required for camcorders, though, so four-pin sockets do the job nicely. Only one FireWire port is required for input and output to the camcorder. Some camcorders also have USB or USB 2.0 sockets. In most cases, these allow the transfer of digital images from a memory card to a computer, but some DVD-based camcorders use USB for video transfer too.

Many camcorders have an extra socket for external control, too, but the type of socket can differ from one make of camcorder to the next. Sony and Canon models typically feature 'Lanc' sockets, but Panasonic and JVC have attempted to compete with this protocol by developing their own – the nine-pin edit port and the JLIP socket. These control ports allow the camcorder to be connected to a linear edit

Four-pin FireWire sockets are the standard for digital video transfer – just make sure that the camcorder has a working DV-input!

controller – a feature that's pretty much redundant now that computer-based non-linear editing is the norm, and camcorders' playback controls can be operated externally via FireWire. One invaluable control available for Lanc-equipped camcorders, however, is the external zoom rocker, allowing zoom, manual focus and recording start/stop functions to be controlled from an external device, often clamped to a tripod's pan handle.

As for analogue video and audio, a typical MiniDV model will offer a composite video port (in which all video information is fed down a single wire), and an S-video socket (splitting tone and colour into two separate channels). S-video is by far the best of the two routes, but analogue copying can still be a noisy, lossy process. At the higher end, HDV camcorders provide 'component' output too, in which video is served through three wires, each carrying one of the picture's YUV channels. Component video can be standard definition or high definition depending on the source material, player and display. Audio is served separately by basic left/right analogue stereo sound feeds.

In a bid to save space, some of these analogue ports are grouped together. Until recently, these took the form of a 3.5mm jack socket, which delivered stereo sound and composite video, leaving a standard S-video port somewhere else on the camcorder's body. More recent camcorders have bundled S-video into the deal too, saving space, but leaving users dependent on specific cables to deliver the higher-quality picture. What's more, the bundled audio-visual cables with these camcorders often include only a composite video connection, making it necessary to buy an optional S-video equipped lead at extra cost.

Manual Controls

Camcorders for the mass market are intended to be used as simple point-and-shoot devices,

making full use of automatic focus and exposure controls. The more interest you take in video, however, the more control you'll want to take over the images you record. More expensive camcorders offer a good range of manual controls, but even then, these might be tucked away in electronic menus (*see* the box below) rather than made available as physical buttons and dials on the chassis. For the budding enthusiast, manual control over focus, aperture, shutter speed and white balance are essential.

Playback Controls

Camcorders also allow video to be watched on the viewfinder or LCD panel. Be careful not to accidentally erase valuable footage if you're shuttling tapes back and forth in the camcorder, though! Larger camcorders have good accessible physical playback buttons, while smaller models must resort to using touch-screen controls in order to save space on the chassis. You might also find that controls are tucked behind the LCD panel, meaning that playback is really only possible using the LCD panel, which drains battery power and can be difficult to see properly in strong sunlight. These are problems that don't affect the viewfinder as much, but the viewfinder is normally switched off while the LCD panel is open.

Battery

Batteries attach to the body of the camcorder or – in rare cases – slot inside. You're unlikely to get a very long-lasting battery in the pack with your camcorder so at least one spare is recommended. Take note of the way in which the battery charges. Some manufacturers provide a separate charger that plugs into the mains power, while others provide only a power adapter for the camcorder and expect users to charge the battery on board the camera itself. This latter situation can be an annoyance should you need to charge one

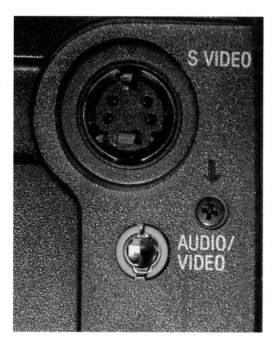

Condensing analogue video and audio channels down to a single 3.5mm jack plug saves a lot of space on the camcorder.

Electronic Features

Physical features and controls can be expensive, but electronic programming is dirt cheap. Expect to see a lot of effects and menu-driven controls on offer when you start playing with your camcorder. Most digital effects can be left well alone – you're better off applying things like this at the edit stage, where they can also be removed if you don't like them. You might find some genuinely useful features though – such as the ability to switch between fullscreen and widescreen modes, and to monitor or adjust audio levels.

29

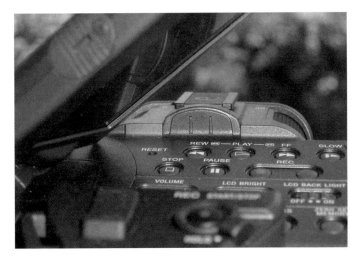

Even on expensive prosumer camcorders, playback controls may be tucked away behind the LCD panel.

Check to see if your battery charges on the camcorder itself or on a separate charger.

battery while using another. Fortunately, the manufacturers that put you in this position sell stand-alone charges at extra expense.

Tripod Mount

The tripod mount is a small threaded hole at the base of the camcorder, into which a tripod will screw. All camcorders have them and, unlike stills cameras, they're usually accompanied by a second hole in which a small stud fits, preventing the camcorder from

The small thread on a camcorder's undercarriage allows it to be mounted on a tripod.

slipping left or right. Beware that some camcorders load their cassettes from beneath: if you end up with one of these models, you'll find yourself removing the machine from its tripod every time you need to change tape!

Memory Cards

High-quality still images recorded by MegaPixel camcorders can't be stored to tape at their full resolution and must, instead, be recorded to memory card. MemoryStick, MultiMediaCard and SDCard are the card formats that you're most likely to discover in the camcorder market, but digital stills enthusiasts might also find themselves dealing with Compact Flash and SmartMedia. One of the most elegant methods of dealing with the many format types (and to prevent you from hooking up the camcorder to your computer every time you want access to a photo) is to invest in a multi-format card reader. They're inexpensive and can stay attached to your computer permanently.

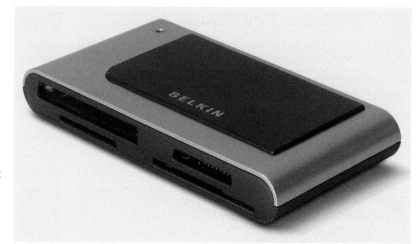

Multi-format card readers are inexpensive and allow you to buy equipment without having to worry about the type of hard-state media used.

BUYING A CAMCORDER

No one camcorder is perfect for everyone, and no matter which one you end up with, you're sure to make a few compromises along the way, be they in features or handling. Always keep in mind the work you plan to do with the camcorder. What kind of videos do you plan to make? Where do you plan to make them? Are you working for yourself or bringing in work from clients? Sad as it might sound, corporate clients often feel more at ease with video makers who have big camcorders, regardless of how good or bad that machinery is. Looking the part can be important, but by the same token, there may be times when you need to blend into the background and look like an amateur – shooting candid street scenes with a big shoulder-mounted beast can attract more public attention than you want.

Another big consideration is price. The most advanced camcorders will do a marvellous job for you, but the expense can only really be justified if you're making money from video. Try not to get suckered into the mindset that work will naturally follow as soon as you've bought lots of expensive kit. That's not guaranteed at all! As a newcomer to digital video, you're better advised to buy what you can comfortably afford and learn to use it well, upgrading to more high-end equipment as the work (and money) come in. Above all else, be sure to look beyond the toys and gadgets – take note of the features that can genuinely help you get the perfect shot. No amount of trickery in the edit room will disguise bad camerawork or poor planning.

Comfort is important. How does the camcorder feel? Do its manual controls fall easily to hand, and can each one be toggled between manual and automatic modes quickly and easily to meet the demands of the moment? Is there individual control over iris and shutter speed? Is manual focus operated by a ring around the lens barrel? By a little dial somewhere on the camcorder body? Or electronically with a touch-screen display? If you plan to take videography seriously, don't compromise more than you have to on manual controls. They have to be accessible and easy to use if you're going to control the image the way you want to.

Common 'gotchas' when buying a camcorder are the discovery that there's no

shoe attachment for mounting video lights or microphones. Some of the smallest or cheapest models are also known to have no microphone or headphone sockets – or to offload them onto an additional base station that adds to the overall bulk and inconvenience.

Possibly the biggest gotcha within the European Union is that many models – particularly at the entry level – have had their DV inputs disabled in order to avoid excessive import duty. The upshot of this is that edited digital footage can't be sent from an editing computer back to DV tape, making these camcorders unsuitable for anyone with plans to trim, tidy and edit their footage. Make absolutely sure that a camcorder has a working DV input before you spend your money!

Even on pricey prosumer models, there can be a need for more shoes!

MORE EXPENDITURE – GETTING THE BASIC ACCESSORIES

Your expense doesn't stop with just the camcorder – make sure you've budgeted for accessories. A good solid tripod is a must, and can make all the difference between amateurish and professional-looking productions. Go for a tripod with a good fluid video head to enable smooth pans and tilts (described in more detail in Chapter 3). Remember, too, that the battery supplied with your camcorder won't give you much shooting time. Buying at least one extra will keep you in business longer. Where possible, spend a little extra on long-life camcorder batteries, giving you one less worry on busy shoots.

An additional external microphone is a must for acquiring clean sound.

Microphone

Microphones should be your next concern. A good shotgun mic will provide a directionality not offered by the camcorder's on-board microphone, giving relatively clean sound, even if you're at a distance from the subject. In an ideal world, however, you want the mic as close to the subject as possible, and if you don't have the advantage of an extra pair of hands to wield a boom arm above people's heads, look for alternatives such as cheap tie-clip microphones or even hand-held interview mics. While it is possible to get through a variety of different jobs with just a single camcorder, you'll probably find yourself using a variety of microphones depending on whether you're shooting talking heads, documentary or dramas where microphones must stay well out of shot. If you've gone for a high-end camcorder with XLR audio sockets, the camcorder itself might provide power to the microphone.

Most camcorders, however, provide only a basic 3.5mm jack socket, meaning that the mic must be powered with its own on-board battery. That's not a huge hassle, but

Many of the more advanced prosumer camcorders have XLR audio connections.

remember that plugging a microphone into a camcorder disables the onboard mic – and so if the external microphone's battery has run out, you'll end up with a silent movie! Buying a cheap pair of headphones will allow you to check that everything's working as it should be.

Video Lights and Reflectors

Video lights deserve some consideration. Advanced users wanting to work in a studio-like environment might be tempted to

33

A lightweight, LED-based video light.

This reflector isn't an expensive piece of video kit – it was originally intended to be placed in car windows!

invest in mains-powered lighting kits, with lamps from 300W upwards. They can be expensive, and take some time to work with as they present safety issues and must be left to cool at the end of each shoot, but they're a good investment for taking full control over the lighting of a scene. On-board video lights are much softer and more subtle, but as they attach to the camcorder's shoe, they always point in the same direction as the lens, flattening the image and removing shadows that would otherwise provide depth and texture. On-board lights can be a lifesaver in situations where there just isn't enough light to get a usable shot, but their creative application is limited. For outdoor shoots in strong daylight, a collapsible reflector, such as those made by Lastolite can be useful for bouncing light into shadow areas and reducing overall contrast.

Carrying Bags/Cases

Finally, make sure to buy a suitable case or bag for the camcorder and small accessories. Don't feel obliged to buy something that looks like a camera bag – there are plenty of discreet solutions out there that look like ordinary shoulder bags, briefcases or backpacks, and they're far less likely to attract the attention of would-be thieves. When buying a bag or case, make sure that the camera and accessories fit snugly inside without rattling around, and that there's enough padding to protect your precious equipment from accidental knocks and bumps.

As we move through this book, you'll discover even more accessories and tools that can make shoots more sophisticated and fun. Always think before spending money, though. Not every toy will be suitable for your type of project or your way of working.

3 IN THEORY

Now you've bought a camcorder, spend some time getting to know it. As we've seen in the previous chapter, there's no one-size-fits-all machine suitable for every video enthusiast, and even the most carefully chosen camcorder is sure to present a number of compromises. As with any tool, it is essential to fully understand a new camcorder's strengths and weaknesses before committing it to serious work.

Opinions can vary as to the best way to use consumer and prosumer camcorders, but ultimately the only right way to operate a camcorder is the one that gets you the shots you need. Never forget that viewers only see the footage you collect. They don't know or care about the way in which it was acquired. Aim to get the best material possible. By any means possible.

LEARN TO BE QUICK ON THE DRAW!

Confidence with a camcorder inspires confidence in others. Leaving your subject waiting around while you hunt for controls won't help them deliver a relaxed on-screen performance. And paying clients are certain to get edgy if they suspect that you don't know how to use your own gear! More importantly, though, slow, fumbled operation can cost you great footage. With the exception of animators

and the most meticulous dramatists, all of us are shooting unpredictable subjects, and camera operators need to be able to adapt to new developments as quickly as possible. Reaction time is crucial. A camcorder's main controls should fall to hand intuitively as and when you need them, but that's something that only happens with practice and familiarisation.

At the basic level, all operators should know how to switch between manual and automatic controls. Most camcorders allow specific features such as focus, exposure and colour balance to be isolated as manual controls while the rest are managed by the camera. Learn how to access and use each manual control without having to stop and take your eye off the action you're trying to capture. Advanced camcorders provide independent control over aperture and shutter speed, lending themselves to the more creative techniques to be discussed later.

Be prepared for extreme shooting conditions too. Prosumer camcorders often have integrated Neutral Density (ND) filters for use in very brightly lit environments: if yours is one of these models, find it and learn how to apply it. Similarly, if the machine allows manual control over sound levels from external microphones, learn to set these too.

The task of familiarizing yourself with equipment goes well beyond the camcorder

itself. Microphones have their own controls, ranging from simple on/off switches (you'll be amazed how easy it is to forget this and shoot mute video) to 'zoom' controls, allowing directionality to be adjusted for distant or single subjects, or more general scenes with many sources of sound. Using lights can be a challenge, too. Aside from knowing how to soften, shape and balance light sources, there are important safety concerns to take into account, from the safe management of cables to fire prevention and safety around water.

Aside from the camcorder itself, the one piece of equipment that makes novices fumble the most is the tripod. Good tripods have small bubble spirit levels, indicating whether the camera is level or tilting – and very good tripods allow the head to be adjusted independently to compensate without having to waste time lengthening and shortening legs to get it just right. Tripods also use screws for adjusting tension or locking them in place. Each one represents a potential motion arc for the camera – such as a pan or a tilt – and it is very easy to get them mixed up. In an ideal situation, you want to be able to release the tripod's pan or tilt function just prior to a camera move. Loosen the wrong screw, and you risk missing a crucial moment or even ruining the shot.

MANUAL VERSUS AUTOMATIC SETTINGS

Purists may insist that video cameras should have their automatic functions permanently disabled and be operated manually at all times. That's fine for large broadcast cameras, designed with manual operation in mind, but the discipline isn't always practical for consumer models, often intended for a 'point-and-shoot' environment.

Drama producers will generally want to work entirely manually, allowing them to compose shots exactly to their liking and exercise complete control over the worlds they're creating. The process of working to a script allows movie makers to take more time

Small domestic camcorders and larger, more expensive prosumer machines differ greatly in the amount of manual control they offer.

over video shoots, often rehearsing actors in controlled environments and working to a storyboard (a collection of drawings to depict each shot visually prior to shooting) so they know exactly what's going to be happening within the frame. Even then, however, some dramatists prefer to improvise, giving cast and crew the freedom to be impulsive. In this case, some compromise over camcorder controls might have to be made to enable snap decision making in improvised scenes.

Similarly, for documentary and event photography, many camera operators will use automatic controls if they're working with unpredictable subjects. Many find that modern autofocus controls do a reasonable job, but also that automatic exposure controls are much more obvious and can yield some very annoying results. Ultimately, it is important neither to be scared of manual controls nor snobbish about automatic settings. They are tools like any other, and the key to getting good results is to fully understand how and when to use them.

White Balance

Light sources that we normally perceive as white very seldom are. Tungsten light bulbs, for example, cast an orange light, but our brains compensate and perceive the light source as white. Light from the sun is given a blue colour by atmospheric effects, and this is intensified if there is a lot of cloud cover, as water vapour absorbs red light. The colour cast by a light source is often referred to as its colour temperature, and measured on a scale based on the colour achieved when a 'black body' is heated. A black body, according to Max Planck (the inventor of Quantum Theory), is an object that absorbs all light and radiation that falls upon it, allowing none to be reflected.

No such objects exist in the real world, but black platinum comes pretty close, and this is used to create a reference guide to colour temperature. The platinum is heated and reference made to the colour emitted as it reaches certain temperatures, measured in Kelvin. Light sources with a low colour temperature appear red while those at the high end of the scale are blue. A tungsten light bulb, for example, will emit light at around 3,000K; this is a similar colour temperature to the sky at sunrise and sunset, but midday sun with a clear sky has a typical temperature of 6,000K, pushing it over to the blue end of the scale. And this temperature increases (and becomes bluer) with increased cloud cover.

When working with film, photographers use filters to absorb colours, and also make a point of choosing 'indoor' or 'outdoor' film, which is intended for use in specific lighting conditions. Things are a little easier with video thanks to the process of white balancing: the camcorder is told what kind of light is being used, and adjusts the balance between red and blue electronically. An object is perceived as white balanced when there is the same intensity of red, green and blue channels, and once white is recognised all other colours should be correctly reproduced. As with most functions, most consumer camcorders will offer an automated white balance control. Some camcorders handle automatic white balance better than others, and it is advisable to do some experimentation under different lighting conditions before deciding to let your machine do the job for you. Automatic white balance can be useful – especially for jobs that have you running between indoor and outdoor locations, but never forget that the camera doesn't actually 'see' and interpret the scene the way we do. And even the most expensive cameras can easily get things wrong.

To avoid unexpected shifts in tone, most camcorders provide simple 'indoor' and 'outdoor' settings for white balance, adjusting picture tone to compensate for the colour cast

Manual white-balance controls on a prosumer model.

of sunlight or tungsten. With many of Sony's MiniDV camcorders, for example, an 'indoor' setting balances the camera for light at 3,200K, while the outdoor setting sets white at 5,800K. Regardless of manufacturer, these options are generally accessed through the machine's electronic menu and result in a clean, well-balanced picture. Just remember to make the change when moving between tungsten-lit interiors and sunny exteriors!

A more accurate, but fussy, method of ensuring accurate colour reproduction is to white-balance the camcorder manually. A white card or object is used as a reference, allowing the camcorder to identify the key light's exact temperature. Not all consumer-level camcorders allow manual white balance, and most of those that do have it tucked away in an electronic menu somewhere, but the majority of 3CCD prosumer models provide a physical white balance button, allowing immediate access. Your choice of object for white balancing is important, however. Don't be fooled into thinking that a white shirt, paper or a freshly painted wall will serve your purpose. Paper, paints and clothes-washing detergents contain optical brighteners that reflect ultraviolet light as visible. That's how their manufacturers can legitimately claim products to be 'whiter than white' – and why they can also provide camcorders with an inaccurate representation of the light source

itself. Photography suppliers should be able to sell you dedicated white cards for this purpose.

For creative purposes, some video makers prefer to white-balance their camcorders with off-white cards, often resulting in richer, warmer tones. As with pure white references, dedicated off-white cards, such as the WarmCards pictured opposite, can be bought, giving controlled degrees of warming or cooling, allowing users to keep the degree of colour shift constant for all shots.

Aspect Ratio

There are two shapes of video frame – the traditional 4:3 'fullscreen' image and the more recent and dramatic 16:9 'widescreen' frame. Most consumer-level digital camcorders can be used to shoot either, but their abilities for widescreen shooting can differ from camcorder to camcorder, as we saw in the previous chapter. While fullscreen and widescreen DV frames have different shapes when played on a TV set, they actually have the same pixel dimensions of 720×576 (or 720×480 if you're shooting NTSC). Widescreen video is 'anamorphic', meaning that the picture has been squashed to fit the frame and is stretched out again on playback to resume its intended shape. The technique has been very common in cinema, particularly in Cinemascope productions for a very wide screen: the shoot would take place with an anamorphic lens to squash wide panoramic shots onto the negative frame, and another lens would then be added to the film projector, allowing the image to be stretched out again.

Anamorphic lenses have come into play in DV productions too, in an attempt to get the best possible quality from camcorders that would ordinarily compromise picture quality when shooting widescreen. In this case, the camcorder would be set to standard 4:3 fullscreen, and the anamorphic lens added to bring in and squash a 16:9 composition. In

White balancing with off-white cards from www. warmcards.com helps create warm or cool colour tones to match the mood of the video.

A 16:9 image as you'd see it on a widescreen TV.

The same anamorphic image as it is actually recorded.

39

post production, the computer would be instructed to identify the footage as 16:9 rather than 4:3, allowing it to be viewed the way the producer intended. Most of today's camcorders handle widescreen video properly, and there's little need for an expensive anamorphic lens for high-quality 16:9. But, as picture is handled so differently between the two aspect ratios, it is best not to mix them in a single project. Sometimes this can't be helped – particularly when editing documentaries using archive footage from different sources, and some editors handle a mixture of formats well, but if it is all up to you, decide on one aspect ratio and stay with it for the whole project.

Aspect-ratio selection is normally found in the camcorder's electronic menus, and that's no bad thing, as it is not a switch that you want to flip during a shoot. Some inexpensive home camcorders, however, now sport a 'wide select' button – somewhat perverse considering that their more useful focus and exposure controls have been tucked away in the electronic menu!

Some camcorders provide a physical button for switching aspect ratio.

Interlaced Video and Progressive Scan

Traditional cathode ray tube (CRT) television sets scan each frame of video in two passes. The image is broken down into separate lines called 'fields', and each pass presents an alternate set of fields. The set of fields comprising the first, third, fifth and so on are called 'odd' fields, while the second, fourth, sixth, etc., are the 'even' fields. Almost all consumer and prosumer camcorders shoot this 'interlaced' video by default, and inspection of frames reveal a slight time delay between the recording of odd and even fields. It is almost as if the camcorder is recording fifty frames instead of twenty-five (or sixty instead of thirty for NTSC), but each at half the full resolution.

This image splitting was necessary in the early days of television to help avoid 'flicker', but is less important today, with the TV market moving over to LCD and plasma screens, which don't scan video images in the same manner as traditional CRT displays. The alternative is to record video with twenty-five single, self-contained frames, rather than fifty interlaced fields – a method known as Progressive Scan. Very few consumer or prosumer MiniDV camcorders offer full-motion progressive-scan video recording – the most notable exception being Canon's flagship camcorder, the XL2 – but that's not to say that there's no demand. Low-budget movie makers like the 'filmic' look that can be had from progressive scan recordings made with a slow shutter speed. The compromise, of course, is fluidity of motion, but many people are willing to make that trade-off for the very subjective difference in image quality. Some ambitious film makers go one step further, looking to progressive-scan video as their key to low-budget cinema, claiming that the progressive-scan frame lends itself better to transfer to film. That might be the case, but film transfer is an expensive business – so much so that it might

Interlaced frames (LEFT) are composed of two sets of alternating fields, while progressive scan footage (RIGHT) presents single self-contained frames.

actually be cheaper to shoot film in the first place. And you'll get an altogether better-looking product if you do!

PAL camcorders that offer progressive scan video run at 25ps (frames per second), while NTSC models have a frame rate of 30fps. The 30fps frame rate has been a big annoyance for those determined to make the transfer to film, as film runs at 24fps, making PAL models – with only a 4 per cent difference in speed – more suitable. For a while, there was a good market for PAL camcorders in the US, until Canon launched its XL2 model. The NTSC version of the XL2 gives a choice of 30fps or 24fps for progressive-scan video; the PAL version is 25fps only.

The new generation of high-definition HDV formats come in two flavours. JVC's offering, pioneered by the GR-PD1 camcorder, allows a choice of interlaced and progressive video running at 25 or 50fps and with a vertical resolution of 625 pixels, while Sony's version – first launched with the HDR-FX1 model – is interlaced and runs at 50 fields per second but has a larger resolution at 1,080 pixels.

As with aspect ratio, once you've decided whether or not to shoot progressive-scan video for a project, it is best to stay with it all the way. Changing between progressive and interlaced modes within a single movie will look odd and

detract from the movie itself. And before committing yourself to progressive-scan footage, consider your reasons for doing so. If the production is going to be viewed on a TV set, there's little value in progressive scan: even though modern LCD and plasma screens don't scan fields in the same way as CRTs, they are still quite capable of displaying interlaced video correctly – they have to as there's so much interlaced material being broadcast! Productions made solely for viewing on a computer monitor can benefit from being progressive, as software players can have difficulty with interlaced media, resulting in jagged edges on moving objects.

Most of all, think long and hard if your reasons for using progressive scan is to attain 'that film look'. Video and film are very different mediums with very different properties. Even if you succeed in making video look like film, it is very unlikely that it will look like good film. Instead, a more sensible decision might be to make your video look like great video – that goal is still challenging but infinitely more achievable!

Focus

Traditional 'active' camcorder autofocus works by sending a pulse of infra-red light out of the lens to measure distance. The light is

Autofocus gone wrong. Note that the subjects are soft while the background is pin-sharp!

reflected from objects back to the camcorder, which then calculates the time taken to return, divides that time by the speed of light and divides the result by two (as the light has travelled to and from the subject, effectively covering the distance twice). Having worked out how far away the subject is, the camcorder then adjusts its focus to match. That's clever stuff, and is a great tool for shooting in low-light environments where good judgement can't easily be made by eye alone. It does have the drawback of being easily confused by other infra-red sources within the scene, and causing some confusion when shooting through glass.

In recent years, a 'passive' method has also been devised, which is now present on the majority of consumer camcorders. In this case, the camcorder analyses the resolved picture, and adjusts focus to maximum sharpness. The process works by comparing the tone of adjacent pixels and attempting to get the highest level of contrast possible. It is an effective system, but can cause focus to 'hunt' in and out in dim lighting or in scenes of low contrast.

Both autofocus methods have one fundamental drawback, in that they have no idea which part of the frame is important to you. As a general rule, they focus on objects near the centre of the frame, regardless of whether your subject is artistically framed to the side. And if someone should walk past in the foreground, the camcorder will become distracted and focus on them for as long as they're in shot. Autofocus has its uses beyond amateur point-and-shoot operation, however, particularly in tricky event videography in which anything could happen at any moment. If composition takes second place to simple documentation, and you trust the camcorder's reflexes more than your own, autofocus can take a lot of pressure off you. If, however, you have a specific planned vision for your movie, and the footage needs to be just so, you'll have no choice but to focus manually.

Camcorders at the top of the consumer and

prosumer range have focus rings, providing a tactile and intuitive control interface. Simply turn the ring clockwise or anticlockwise until the picture comes into focus. In recent years, however, focus-ring controllers have been lost from consumer camcorders – partly out of necessity as the machines are made ever smaller, but also possibly based on a belief that nobody will actually bother to focus manually. Where no physical focus controls can be found, you may find yourself hunting in the camcorder's menus for them!

Regardless of how easy or difficult a camcorder's focus controls are to find and operate, achieving pin-sharp focus is a simple process once you realise that focus is not affected by a camcorder's zoom. To ensure that your subject is sharp, zoom right in (ideally on the eyes if your subject is human, animal or potato), bring it into focus using manual controls, then zoom out and reframe as required. Many 3CCD prosumer camcorders feature a 'push auto' button, which take it out of manual focus mode for just a moment – a great feature in this context if you only have a split second to get the subject sharp.

Focus pulls, in which the operator shifts focus between two subjects in the same frame, are hard to achieve with any consumer or prosumer camcorder, thanks to the fact that lenses aren't calibrated by distance. The effect can be achieved, but only with a practice – don't bother trying if you only have one crack at the shot! Focus pulling is covered in Chapter 5, so skip ahead if you are feeling brave.

Some recent camcorders have a 'Spot Focus' tool, accessed through the electronic menu. Using touch-screen controls, the operator taps the LCD panel to select the object that they want in focus. It is a new way of working focus controls and a very intuitive one for the novice. In my own tests I've found that these camcorders can take some time getting the focus right first time, but they learn quickly as you shift their attention back and forth between objects in the same frame, making the concept of focus pulling somewhat less daunting.

Exposure

Humans are able to see and perceive detail in bright highlights and deep shadows all at

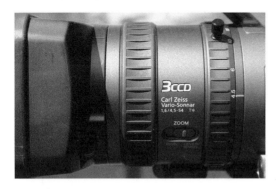

Good prosumer camcorders have physical focus rings, although they are not calibrated by distance in the way that true professional lenses are.

Many small consumer camcorders save on space and cost by moving manual focus to the electronic menu; some, however, have introduced excellent Spot Focus tools.

Zoom close in on a subject to ensure a sharp focus.

Zooming out again to reframe will not affect focus.

Push auto buttons can be a great asset for quick focusing in difficult situations.

once. Video and film aren't nearly as versatile, and can only resolve detail in a very limited brightness range. For that reason, it is important for a camcorder or its operator to make decisions regarding the exposure of a scene, to ensure that the necessary details aren't burned out in highlights or lost to shadows. In drama productions, the environment is controlled with additional lights. A set that might appear flat and uniformly lit to the naked eye can look rich and deep when seen on film or video. Real-world exteriors aren't quite so easy to control, and while I'll soon be coming to methods of bouncing and softening natural light sources, you'll still have to make some tough choices regarding the detail you want to keep, and what will be lost to shadows and highlights.

A camcorder's automatic exposure controls are designed on the assumption that all the shadows and highlights within a certain frame will average out at a mid-grey tone. That might be fine for general point-and-shoot operation, but isn't a great help when working with

high-contrast scenes or working with subjects set against large expanses of white or black background. In some situations, automatic exposure controls can be more obvious and more annoying than autofocus. Panning past bright light sources such as windows, for example, can drop the rest of the scene into darkness for a moment or two. And zooming into dark corners of a scene can result in a sudden bloom of detail as the camcorder's iris springs open to compensate for the reduction in incoming light.

Unlike focus, exposure is determined by two sets of controls – the iris (also known as aperture), and shutter speed. Each can lighten or darken an image, but have their own distinct influence over the picture itself. Aperture works like the iris of an eye, controlling the amount of light that enters the lens. It is the feature that's most often used to correct exposure, but has a knock-on effect of altering the scene's depth of field (the area around the current focal point in which objects remain in focus). A wide aperture reduces depth of field, while the smallest aperture gives a greater depth of field, sometimes resulting in an image where everything's sharp. Shutter speed controls the amount of time that light is exposed to the camcorder's CCD for each frame. Increasing speed reduces the amount of exposure, and therefore darkens the image, while a slower speed allows light in for longer, giving a brighter image. Changing shutter speed can also reduce or accentuate motion blur in a scene, however. I'll be covering the creative application of depth of field and motion blur in later chapters.

Good 3CCD prosumer camcorders provide physical aperture and speed controls, but there are no rules or conventions dictating where they'll be placed or what form they'll take. On some camcorders, the iris control is a wheel control, while on others it may be a dial or a pair of 'plus' and 'minus' buttons to increase or decrease aperture. Shutter speed, however, normally takes the form of a single button, used to toggle through the camcorder's range of settings. Cheaper 'consumer' models are far less likely to have physical exposure controls, and users will have to enter their electronic menus to access them. What's more, many camcorders targeted at the 'home' market provide very limited control over shutter speeds, save for some rather generalized options among their 'Program AE' modes.

Shot exposed for the subject. Notice how the background is heavily overexposed to compensate.

Now exposed for the background, dropping the subject into shadows.

A fast shutter speed is used here to reduce motion blur and keep water droplets sharp.

Slowing the shutter speed makes water appear to lose its form and solidity.

Program AE modes allow the camcorder to make informed decisions for its automated exposure controls. It is almost as if the camcorder is being told what kind of conditions you're shooting under. A setting common to most camcorders at all levels is 'Spotlight' mode, which informs the camcorder that the scene may contain large amounts of dark shadow and high contrast. The camcorder will then expose for the highlights rather than aim for an average of the whole scene, which would result in an over-exposed picture. 'Backlight' modes work the other way, telling the camcorder that the

A combination of long lens and open iris helps reduce depth of field, softening background and foreground.

subject is framed against a very bright background, such as a window. With backlight mode selected, the camcorder will expose for the scene's shadow detail. Other AE modes typical to consumer camcorders include a 'Sports' mode, which increases shutter speed to minimise motion blur on keep fast-moving objects. There is often a slow shutter mode too, allowing bright but murky footage to be shot under dim lighting. A 'sand and snow' mode is also useful when working in environments with reflective surfaces, such as snowy mountains or seascapes, where reflected light can throw off the automatic exposure settings.

As with Spot Focus mentioned earlier, some new camcorders provide 'Spot Metering' functions, whereby users tap the LCD screen to identify regions of the frame that are to be exposed correctly. Again, it is a good step forward in providing intuitive and tactile controls over the video image – especially when working with consumer-level camcorders, where manual controls are often tucked away in electronic menus in the belief that nobody will ever want them.

Bright sunny days can kill good video footage if the camcorder isn't equipped with a neutral density (ND) filter. ND filters make no aesthetic impact on the image being shot – they simply reduce the amount of light coming into the CCDs. Prosumer models have integrated ND filters, which are called into play manually or electronically when the scene becomes too brightly lit. Home camcorders are less likely to have this feature, and once the iris has closed as far as it can, the camcorder will be forced to increase shutter speed dramatically if the scene is still too bright. The result is hard and sharp footage that seems to jerk and strobe on camera movements. Good camera shops sell inexpensive ND filters, however, which screw on to the front of the camcorder's lens and serve the same purpose

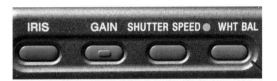

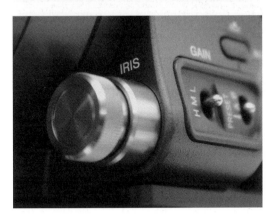

Good prosumer camcorders provide independent physical controls for iris and shutter speed.

as a prosumer model's internal filter. It is a very worthwhile investment if you're taking the camcorder away on a sunny holiday – just remember to look up the camcorder's filter diameter before you go shopping.

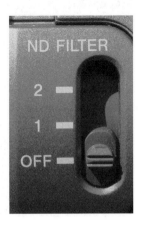

ND filters reduce the amount of incoming light – very useful when shooting in very strong sunlight.

47

Digital Zoom and Optical Adapters

Modern DV camcorders have immensely powerful digital zooms, sometimes reaching such extremes as 800×. Switch them off. Do it today and never touch them again. You won't find digital zooms on expensive pro camcorders, and there's one good reason for that – the pros know better. If you have read the previous chapter you'll know that digital zooms result in lousy pictures and you're better off without them. Optical zooms on modern camcorders are powerful enough for most situations, and if they are not, then get closer to the subject!

There will be occasions when the zoom range of a camcorder's lens isn't sufficient for a particular shot, be it at the wide or telephoto end, but on no account should you consider using the machine's digital zoom. All good camera shops stock a range of optical add-ons for just this purpose, and you should be able find one that matches the filter diameter of your camcorder. Such adapters can double your focal length to increase maximum zoom by a factor of two, or reduce it to give you extreme and dramatic wide-angle shots. Prices for these adapters can vary greatly, and it is important to realise that you get what you pay

Digital zooms enlarge an image after it has been processed by the camcorder's CCD, with generally hideous results.

for with regard to optical precision. A precise lens adapter will cost you more, but give a much better picture than a cheap, mass-market one. But however much you spend, the result will always look a whole lot better than if you were to zoom electronically.

USING A TRIPOD

Tripods are inconvenient things. They're extra bulk to carry around, and can significantly slow down the process of shooting. For the uninitiated, they can be clumsy to use too. And, if we're being honest here, that sleek, tiny new camcorder will look a bit daft sitting atop three big legs. But as unattractive as they might be, tripods can make all the difference between amateurish video and a polished production.

On a basic aesthetic level, video shot on a tripod has an objective feel, making the operator's role much less obvious than hand-held footage, which often conveys the sense of a very subjective point of view and can, in some cases, be regarded as confrontational. Tripod operation is also much more controlled than hand-held shooting, keeping the camcorder dead still where necessary, or panning and tilting in smooth arcs. Tripods help improve picture clarity, too. We've already seen the way in which moving objects appear blurred in video frames – the same kind of blur applies with hand-held shooting. Granted, a gentle wobble causes far less motion blur than a speeding car, but the effect is there. It affects the whole frame and can add a slight muddiness to material that would have been pin-sharp if shot on a tripod. What's more, the process of using a tripod can force users to think about their shots far more than a hand-held operator, who might be tempted to just point and shoot.

I would never suggest that you use a tripod at all times regardless of circumstance – done

Lens adapters are a good investment, but vary greatly in size, precision and price.

correctly, shooting hand-held can create a lot of drama and help involve viewers in your movie. But it is a sensible approach to work hand-held only when you have a clear reason to. If you're in any doubt, err on the side of caution and mount the camcorder on sticks.

Mounting and dismounting the camcorder will be made easy by a quick-release plate – now a standard feature of most tripods. The plate is a small piece of metal that screws into the tripod thread at the base of a camcorder, and then clips onto the tripod itself. Removing the camcorder is then a simple matter of releasing the plate rather than of unscrewing the camcorder. If you're one of those unfortunate souls that has a bottom-loading camcorder, you'll find that the quick-release plate will need to be removed every time you need to change tapes.

Setting the tripod with a good spread to the legs helps ensure stability, and it is important to check that its telescopic legs are locked in position and won't start to slide in mid-shot. It is also essential to check that the camcorder is straight before you shoot a frame of footage.

Quick-release plates are a blessing for the immediate mounting or removal of a camcorder from its tripod.

Bubbles help you check that the tripod is level.

Adjusting the centre column provides a quick and easy way to raise or lower the camcorder – but make sure the tripod doesn't overbalance!

Good tripods are equipped with a simple bubble spirit level, making it easy to tell whether or not the camera is level. A professional tripod is composed of a separate head and legs. With these supports, the head can be tilted and repositioned independently of the legs to straighten the camcorder. Adjustment of cheaper one-piece tripods isn't so easy – you'll need to lengthen and shorten legs to compensate for and dips and inclines in the floor. It is worth the effort, nonetheless. As a final check, inspect the scene in your camcorder's viewfinder or LCD panel. Horizontal lines will often appear squint, depending on the angle at which you're viewing them, but vertical lines should always be straight up and down and, as a test, line up perfectly against the sides of the frame.

For quick adjustment of shooting height, pay attention to the tripod's centre column, which can be raised without having to readjust the legs. It is a quick and easy way to gain more height, but be aware that the higher you take the camcorder on the column, the less stable it will be. Just how stable or unstable the set-up is depends greatly on the weight of the camcorder and the tripod, along with the extent of its spread. You will also find that the camcorder's LCD side monitor becomes invaluable when shooting at very high and very low angles.

Tripods allow two types of motion: pan and tilt. Both movements swing the camcorder around its own axis, the pan moving it left to right, and the tilt it moving up and down. All movements are physically operated using the tripod's pan handle, but are enabled and disabled with their own screw controls. These can also be used to alter resistance to each motion, allowing fast pans and tilts, or forcing them to be slow and steady. These screw controls are also essential for locking off the tripod to prevent movement. Not only will there be times when you want to keep the

camera motionless, but locking off the head is an important safety measure to prevent unwanted movement when the kit is left unattended on the tripod. A heavy camera allowed to tilt on its own can shift the centre of balance enough to topple the tripod, potentially causing hundreds of pounds' worth of damage.

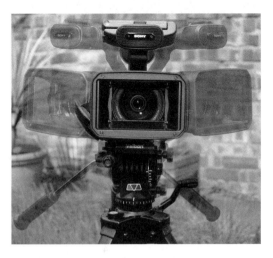

Pan motion.

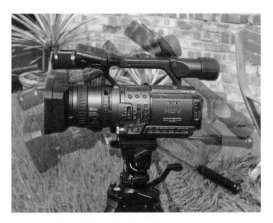

Camera tilt.

Locking screws enable – or prevent – camera movement such as panning and tilting.

RECORDING SOUND

Sound is every bit as important to video as the picture itself, and careful recording and mixing can make good movies great. Creative use of sound fills in gaps that are left in visuals, convincing viewers that multiple cameras were used for complex scenes, or that footage was shot in hostile terrain rather than in your back garden. Audio is overlooked by far too many movie makers, and that's a shame as sound design can be just as exciting and fulfilling as shooting the visuals.

DV video uses uncompressed PCM digital audio, and there is normally a choice of two quality settings. Digital sound quality is defined in terms of sample rate and sample size. The sample rate is the number of times a noise is sampled per second. Sound on audio CDs, for example, is sampled at 44.1kHz, meaning there are 44,100 samples recorded for every second of the recording. 'Sample size' indicates the amount of data allocated to each of these samples. It determines the dynamic

range of recorded audio and is measured in bits. CD audio has a 16-bit sample size, which is also the norm for DVD-Video soundtracks, while the higher-quality DVD-Audio standard is 24-bit. As an analogy to video, sample rate can be compared to a picture's pixel resolution, while sample size is more like the size of the picture's available colour palette. MiniDV offers a single 16-bit stereo track at 48kHz resolution, or two lower quality 12-bit stereo tracks at 32kHz.

For most jobs, 16-bit audio is the most appropriate choice, being the better quality option, but 12-bit audio does have its uses. Many professional camcorders allow both 12-bit stereo tracks to be recorded to at once – often used as four mono channels so that complex interviews can be conducted with each participant mic'd individually. And while this isn't a common feature of cheaper domestic camcorders, some of Sony's latest models use it to record a surround-sound mix using an optional four-channel microphone. At the time of writing, the surround mix can only be accessed properly on a Sony Vaio computer, but the idea is strong enough to be picked up by the competition and become a mainstream DV feature very quickly. Even working with a single 16-bit stereo track, it is worth remembering that it can be treated as a pair of mono channels for interviews. A pair of tie-clip microphones and a stereo jack splitter will allow two subjects to have their voices recorded independently for remixing later.

HDV video formats use compressed MPEG audio rather than uncompressed PCM sound, allowing more of the total data stream to be allocated to picture. MPEG-1 Layer 2 sound is the standard of the VideoCD format and quality can be poor in comparison with uncompressed recordings, but the first generation of HDV camcorder seems to do a good job with it. Only one stereo track is available for HDV recordings, however.

In the previous chapter, we looked at the different types of microphone that are available. Plan your shoot and make sure you use the right type of mic for the job. Tie-clip mics or hand-held interview microphones are no trouble to work with, as they're in-shot and up-close to the subjects. Things get a little more tricky when you're trying to keep the microphone out of shot, however, and I'll be introducing sound technique in Chapter 4. In the meantime, it is a good idea to invest in a boom pole (or adapt a broom handle to accommodate a microphone), but only if you're working as part of a team and have someone on hand to hold it. Just as it is important to use an external microphone for close-up recording of your subject, it is important to plug headphones into the camcorder, too. Most camcorders disable their own built-in microphone as soon as a new one is plugged in. If the external mic has a flat battery (or just isn't switched on) you'll end up with mute video. Adding a pair of headphones will alert you to such problems. It doesn't have to be an expensive set – just something that will confirm that sound is being passed to tape.

Sound recording controls are another area where more expensive 'prosumer' camcorders shine compared with domestic models. Good 3CCD camcorder allow users to take manual control over sound levels. As with focus and exposure, automatic audio gain can give poor results, fluctuating at inappropriate times. For example, any loud noise will cause the audio gain controller to dip, and it may take a second or more for levels to rise again – and the effect is very obvious when such noises occur in the middle of dialogue, interview or music recordings. Manual controls are often accompanied by visual representations of sound levels on the left and right channels of the stereo mix, although the controller itself may not be able to affect them independently.

LIGHTS – A WORD ABOUT SAFETY

Large video lights are a great asset to productions if used properly, but they do represent a potential hazard for you, your team and the general public. Spend some time and thought on making sure they're set up safely. For a start, any power cables need to be taped down to ensure that passers-by don't trip over them. Gaffer tape or duct tape is an essential part of any equipment bag, and I'd recommend buying a lot of it, as you will often find yourself taping down long lengths of cable. Cable ties are also massively useful for securing hanging cables, should lights or microphones need to be mounted at ceiling height.

Lights get very hot! Always allow time after a shoot for lights and any attached diffusers or barn doors to cool before handling them or packing them away. When shooting on location, make doubly sure that powerful lamps are not set up next to curtains or other hanging fabrics, as their heat can be more than sufficient to start a fire. Also take care with gels and diffusers. Any coloured gels that

Gaffer tape or duct tape is essential for securing trailing cables.

come into direct contact with the lamp are likely to melt, and dusty diffusers can give off a lot of smoke – all of which can set off smoke alarms and rob you of precious shooting time.

Another consideration is that lamps tend to be heavy, while their stands are generally lightweight with a narrow spread to the base. The higher you position a lamp on a stand, the more unstable it will be. Sandbags placed on the base of the stand will help prevent it from toppling and breaking or, worse still, injuring others.

Electricity and water make a bad combination, so never touch or move lights or their cables with wet hands. For the safety of others, think long and hard before setting up lights near swimming pools or similar locations. A mains-powered lamp can hurt a lot of people if it topples over into water. If you really need additional lights for such a location, use battery-powered sources instead!

ONE FOR THE BUDDING PROS...

Always try to have a spare everything. There will be days when, for whatever reason, something in your toolbox just won't work. If you are being paid to deliver a video production, there are no excuses that can save you if you are unable to do the job. Your client wants a finished product and doesn't care what you have to do to deliver. Everything you have needs a back-up, regardless of how insignificant it may appear. If electrical devices have detachable power cables, bring spares – it is much quicker to swap over a flex than to start unscrewing a plug to change a blown fuse. Spare camcorder batteries are a must, as are spare video and audio tapes. If video brings in money, invest in a back-up camcorder – you won't want to turn down work if your main camera needs servicing. It doesn't need to be the same model as your main camcorder, but choose something from the same manufacturer if possible and go for a 3CCD model if your main camcorder is a prosumer machine – this way you'll be able to achieve a close colour match when shooting multi-camera work.

If having back-ups of every single device is too costly or impractical, give thought to how you'd proceed if a certain item was to fail on you. If a dedicated sound recorder dies, how would you connect microphones and mixers to the camcorder itself? If you're relying on feeds from a venue's sound desk for a concert shoot, are you prepared with adapters to accommodate all the different types of balanced and unbalanced audio connection you could be offered? Careful planning should take care of most potential headaches, but it pays to be prepared for unexpected surprises on the day.

4 IN PRACTICE

Knowing how equipment works is only the first step toward shooting good video. A clear understanding of the basic language of video is also essential before you start shooting. In this chapter, we shall be looking at the different types of shot typically used in a movie, as well as techniques for recording clean sound and ensuring that shots will hang together well as an edited sequence; lighting basics and camera movement will also be covered. While this is all important information, none of it can really stand up without a purpose and a creative context. If you are just dipping into this book, be sure to read this chapter and the next together, so as to understand how these techniques apply to creative decision making.

THREE TYPES OF SHOT

'Shot', in the context of this book, is a word used to describe a single, uninterrupted piece of video or film footage. At the most basic level, shots fall into three basic categories: long shots, medium shots and close-ups. The terms describe the way in which a subject is presented within the video frame, but only go a very short way to describing its content and style.

A long shot presents the subject at a distance. If the shot is of a person, most (if not

A long shot, framing subjects full-figure.

all) of their height will be presented within the frame. Long shots provide a general view of a scene, putting a subject into context before we move in to see more specific detail. For that reason, they are often used as the opening shots of a scene, allowing viewers to get their bearings in the first few seconds.

Moving in slightly, we come to the medium shot. Again, if a person is the subject, a medium shot will present them from roughly the waist up, making them more dominant within the frame, but allowing us to keep a comfortable distance from them.

Close-ups concentrate on the subject's face, letting us focus on the fine details of their expressions and adding massive emphasis and importance to whatever it is they are saying, thinking or doing. The classic close-up holds the subject from the shoulders up, but greater extremes are easily found in mainstream

A medium shot, framing the subject from the waist up.

A close-up, consisting of the head and shoulders.

Miking Subjects

Sound is just as important to a production as picture. Even with the best photography, a video will appear amateurish and shoddily made if the soundtrack is poorly recorded. At the shooting stage, aim to make all sound recordings as clean as possible – you can always add ambience effects and distortion later if you need them. When it comes to recording speech, try to get the microphone as close to the subject as possible. In dramas, where the microphone must remain out of shot at all times, mics are often suspended above the actors on a long pole called a boom. The mic is positioned above the actor, just slightly above the top of the frame, so as not to be seen. Doing this requires an extra pair of hands just to hold the boom pole, which can be impractical if working solo or as part of a very small team.

An alternative is to mount a directional shotgun microphone on a stand, just to the left or right of frame. Either way, the microphone should be pointing directly at the subject's mouth. For documentary and interview footage where microphones are allowed to be seen in the video frame, close miking of subjects is easy. Hand-held microphones provide the most straightforward approach, and require very little planning or preparation, but tie-clip mics can give a more natural result and put your subject more at ease – especially if they aren't used to handling microphones day-to-day.

cinema – usually concentrating purely on the eyes.

These three types of shot can be applied to any subject – not just people. Buildings, machinery and inanimate objects can be presented in their entirety or in varying degrees of detail. Landscapes and interiors are generally presented only in establishing wide shots, however.

EYELINES AND LINES OF ACTION

Continuity is important when editing shots together into a narrative sequence, and how a subject moves within the frame is just as important as whether they have changed their tie or shaved off their beard between shots. If, for example, we were to shoot video of a cyclist, moving left-to-right in the video frame, we'd want to ensure that all shots in that sequence had him moving in the same relative direction. An easy way to do this is to plot a line along which the bike will travel, and to keep the camera on one side of it. If we cross the line, the bike will appear to have changed direction, now moving right to left.

The same rule of a 180-degree line applies to confrontations between two people. Consider a tennis match, for example: by drawing an imaginary line between the two players and staying on one side of it, we can cut between them and retain the sense that they're facing each other. Cross the line, however, and the edited sequence will give the impression that they're hitting the ball in the same direction.

In conversations, interviews, dialogues and even dramatic action sequences, apply the same rule to eyelines. Do people appear to be maintaining eye contact from one shot to the next? The more people, actions and objects are involved in a scene, the more complicated it becomes for controlled dramas. Having a pen and paper to hand can be a massive time-saver when it comes to planning out camera positions. Of course,

All the shots for this chess game sequence were taken on one side of an imaginary line drawn between the opponents.

you can avoid many headaches on the day of a shoot by thoroughly planning and storyboarding in advance.

HARD AND SOFT LIGHT

Quality of light is determined by the size or distance of the source, and is referred to as being 'hard' or 'soft'. Hard light can be created by small point sources such as directional spot lights, but one of the hardest-light sources available to us is direct sunlight – even though the sun is massive, it is far enough away to behave in the same way as a small, directional lamp. Hard light casts very strong, sharp shadows, ultimately giving a very high-contrast image. A single hard-light source can give very striking effects, and consideration should be given to the direction of light: a strong blast from the front will severely flatten the image and strip away detail and texture in the same way that a camera's flash does. The more a light moves to the side of a subject, the longer shadows become, until the subject is dropped into silhouette as the light moves round the back.

Soft light is cast by larger (or closer) light sources and give a more subtle effect with soft

A simple diffuser called 'spun' is attached to the front of this lamp.

shadows and reduced contrast. Large lights scatter rays in many different directions, unlike very directional pinpoint sources. An object in the path of the light won't block it entirely, and shadows won't be as solid and precise. Hard lights can be softened using diffusers: in the studio, gauzes and translucent fabric boxes are used to soften lamps, while in nature the sun is softened by increased cloud cover. The softest light is reflected light, however – light that is bounced off ceilings, walls and floors. Video shot in a shaded

ABOVE: *Hard lighting casting strong, well-defined shadows.*

RIGHT: *Soft lighting is more subtle and the source of light is often difficult to pinpoint.*

59

environment with no direct sunlight can give very little indication of where the light is actually coming from, and that makes life easy from a continuity point of view – far more so than working under strong directional sunlight that moves throughout the day!

KEYS, FILLS AND BACKLIGHTING

The human eye and brain can handle a much higher degree of image contrast than film or video. Lighting conditions that might seem reasonably well balanced to the naked eye can often appear excessively contrasty when captured on film, with burned out highlights and pitch-black shadows. In many cases, you will need to cheat by reducing the tonal range of a scene in order to make it look natural on screen.

The main form of illumination in a scene is called the 'key light'. In an exterior shoot, the key light would be the sun. In an interior or studio environment, the key is the strongest light source in the set-up, often used to simulate sunlight. In the example (*see* picture below left), the key light is located at

45 degrees to the left of the camera, casting strong, solid shadows onto the right-hand side of the subject. Notice that in exposing for the key light, we have lost all shadow detail.

Shadow detail is reclaimed using a 'fill' light. It is this fill that cheats the environment, reducing the scene's contrast and bringing it more in line with the way we expect to perceive things. The fill should be softer than the key light, and positioned at the same height or slightly lower. While the fill's intensity can be adjusted to suit the mood you want to create, it shouldn't be more than half that of the key light. As for position, place it on the opposite side of the camera to the key, but at a slightly asymmetric angle – in the picture (*see* picture below centre) it is slightly closer to the axis of the camera than the fill light is. The fill doesn't necessarily need to be a lamp – in brightly sunlit exteriors and many studio settings, fill is simply bounced back into shadows using a reflective surface such as a Lastolite reflector or even just a big sheet of white card or polystyrene.

Backlighting is a device used to separate the subject from its background by casting a slight

Key light provides the main source of illumination, but can result in a high-contrast image when used on its own.

Fill can be bounced in from a reflector or introduced from another separate light source.

Backlighting can help separate subject from background.

Object-Specific Light Sources

Props or objects within the set can provide their own light sources and, if used well, help evoke a good sense of atmosphere. An obvious example is candlelight used in religious and romantic contexts. If the camcorder's low-light capabilities are good enough to use candlelight as its main form of illumination, the results can be quite striking. Even used as a fill, candles bring a lot to the image, bringing good colour and unpredictable movement. Other sources of light to experiment with include electronic devices such as TV sets, computer monitors and mobile phones. Reflective light sources can also be used for dramatic effect, a crude example being light reflected from a knife in a 'slasher'-style horror movie, but other more subtle sources can include simple items such as water and glass.

halo effect around the borders. It shouldn't be overdone, but when used subtly, it adds a good deal of depth and definition to the composition. Backlights are relatively dim lights, positioned behind the subject, higher than the key or fill.

Bounced Light, Barn Doors and Flags

When working with lamps, it is often unnecessary to point them directly at the subject, particularly when shooting in small rooms. Direct illumination can make actors and interviewees uncomfortable and force them to squint. You also may not have the time, space or need to set up key, fill and backlights – your need might simply be to increase illumination for a clean image. If that is the case, bouncing a single light off the ceiling might be all that is needed to boost the amount of ambient light in the room.

In a more carefully controlled set-up, however, additional lighting may also be required to pick out details of the background or surroundings that may otherwise fall into shadows once the subject is properly lit. Small lamps are invaluable for picking out details such as clocks or ornaments, but take care not

to make them so bright as to distract viewers from the actual subject. Careful placing of highlights takes time, however, as care must be taken not to cast light where it is not wanted. Video lights normally come with 'barn doors' – metal flaps on the lamp itself. Opening and closing the doors serves to control the spread of light, casting it only into certain areas. Barn doors are also useful for attaching diffusers and coloured gels if needed.

Yet more control over the areas in which light falls can be had by setting up 'flags' on

Barn doors on the front of the lamp help direct light and retain shadows where they're needed.

location. Flags are large wire rectangles with opaque black fabric stretched across them. They are set up on stands between the light and the subject. Bringing a flag closer to the subject can create a stronger edge to the shadow it casts. Narrow flags can be used to create a stripe of shadow that wouldn't otherwise be possible using just the barn doors. This degree of lighting control is time consuming, but for dramas, corporate productions and advertising, the time is well spent to create just the right look and feel for your image, and to carefully direct the viewer's attention.

CAMERA MOVEMENT: BEYOND PAN AND TILT

The pan and tilt camera movements we looked at in the previous chapter have the camcorder have the camcorder supported on a tripod in a specific location and move it around a fixed axis. For more elaborate shots, you will want to shift the camcorder's position altogether. Elaborate camera moves require more equipment, more expense and more time spent in preparation. They are also difficult to manage when you're working solo, as at least one extra pair of hands is almost always required.

Tracking

A tracking shot is one in which the camera moves in a smooth path – usually forward and back, or left and right. As the name suggests, the camera is mounted on a platform (known as a dolly) that runs on tracks. Big-budget productions often use great lengths of track with curves and turns to get the camera exactly where it is needed. For more compact shoots, shorter lengths of track can still help to breathe life into a shot and help involve the audience more than a passive static shot might. Tracking typically involves at least two people: one to operate the camera and one to

push it on the tracks. The small, lightweight quality of digital video camcorders opens doors for smaller, lighter tracking equipment too, however. Companies such as B. Hague are known for a healthy line of DV-related solutions, such as a small dolly that runs on aluminium ladders.

A nice alternative is a simple trackless dolly. This connects to the bottom of a tripod, locking the feet in position like a spreader, but is also equipped with a set of wheels, allowing the camcorder to be rolled about freely. Motion isn't quite as fluid and controlled as with a track, but it does afford a little more freedom and can be operated single-handedly. These dollies are, however, very dependent on having solid, smooth, flat surfaces on which to roll.

The most budget-conscious movie makers are known for their creativity in finding 'things with wheels' for performing tracking shots. Wheelchairs, skateboards and shopping trolleys have all served to get cameras on the move!

Jibs and Cranes

Jibs are small, carefully balanced arms that move the camera smoothly up and down. The arm is hinged at the base to provide the main pivot to gain height, while a second pivot simultaneously tilts the camera to ensure that its relative angle to the ground isn't changed during the move. Arms can be swung left and right to pan scenes, and controls of the top pivot allow the camera to be tilted, too. Small jibs can be mounted on the top of sturdy tripods and these in turn can be set on dollies and tracks, to enable some very sophisticated motion. In theory, the extension of a jib arm shouldn't overbalance its support, as it is weighted on both ends to maintain a careful balance. It should be noted though, that the camcorder's LCD monitor won't be properly visible at all stages of the jib's elevation, but an additional LCD display can be bought and

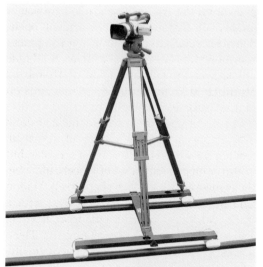

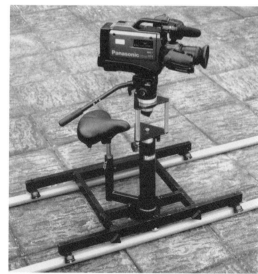

ABOVE LEFT: A small track and dolly to accommodate a normal tripod, as made by B. Hague.

ABOVE RIGHT: Larger set-ups can include a seat for the operator!

CENTRE RIGHT: A trackless dolly set-up, simply adding wheels to the bottom of a good solid tripod.

RIGHT: A simple jib, providing smooth vertical movement as well as easy access to high and low angles.

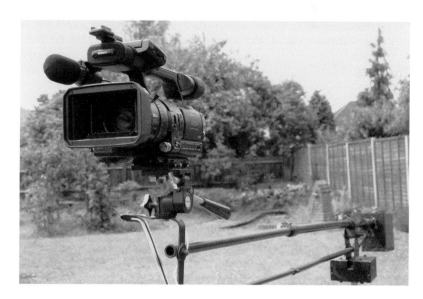

mounted at the base where it can be seen at all times.

Cranes do very much the same job as jibs but to a greater degree, elevating the camera much higher. At these heights, a separate video monitor is essential at the operator's eye level, so you can see what you are getting on tape. Cranes and jibs also allow you to drop the camcorder to very low levels, allowing you to shoot from floor level or even descend below balconies, ditches or cliffs if you're feeling brave.

Hand-Held Movement

It is, of course, possible to move camcorders without the need for tracks, dollies, jibs and

Sound: Recording Silence, Spot Effects and Wild Tracks

During the main shoot, your priority for sound will be to get clean speech from your subjects. While the cameras is rolling, you want to make sure that background noise is kept to a minimum. Don't allow any music to be played in the background. It cannot be removed from the soundtrack, you will have to pay royalties for its use in the finished video and every time you cut the picture, the record will 'jump'. Caution should also be taken with background chatter. An incomprehensible gaggle is all well and good, and we can mask it further with wild tracks at the edit stage, but if there's any possibility that unwanted words and sentences will be audible in the background, politely ask them to shut up, as stray conversation will again limit your options for seamless cutting. Locations with regular chimes or machinery noise should also be avoided if possible.

Having spent time keeping background noise out of your video, you will have to spend more time recording some to add into the edit. This might seem daft, but the method is a sound one, giving more control over the balance of foreground and background noise, giving depth to stereo and surround-sound mixes, and helping to cover edits and keep the sequence moving seamlessly. Sound can be recorded directly onto video tape – just keep the lens cap on, and speak into the microphone before each take, so you have a reference of what is being recorded. Get the mic up close to any props or set dressings that make a definite noise, such as telephones or clocks. Also, make some recordings of footsteps and walking sounds to add in later. They needn't be in sync with the footage at this stage – all that can be fixed in the edit.

'Wild tracks' are also important to smooth editing. A wild track is a continuous piece of atmospheric sound recording. It might sound boring, but hidden in there somewhere could be the noise of traffic passing by outside the window, fridges humming or halogen lights flickering. Laying a wild track down on top of an edited video sequence helps secure the illusion of the events on screen happening in real time, serving to make the overall editing process invisible. Wild tracks can also be recorded directly to the camcorder using a good microphone. Make sure there is nothing distinctive caught on tape – such as clock chimes or specific voices – as these will become a nuisance if you need to loop the recording over long sequences. Also, don't feel obliged to record wild tracks at the same time or at the same place as the actual shoot. Many studio-based productions record video on a sound stage, then pull in wild tracks from real locations so as to pretend that events aren't taking place on a cardboard set. Find the sound that creates the atmosphere you need for the video, regardless of whether that atmosphere existed on the day of the shoot.

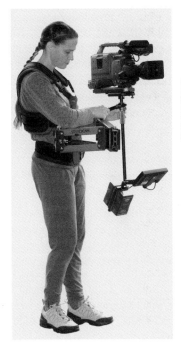

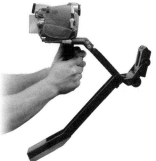

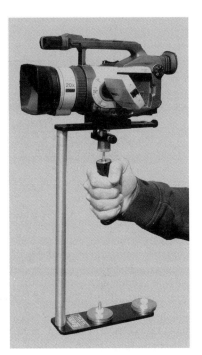

ABOVE: A lightweight Steadicam option for lighter hand-held models.

LEFT: A sturdy Steadicam rig for medium-weight prosumer camcorders.

RIGHT: A similar image stabilizer from B. Hague.

cranes. Simply picking up the camera and carrying it will do the job, but the results are generally rather wobbly. Well-respected movies, such as Steven Spielberg's *Jaws* and John Frankenheimer's *Seconds* have been shot almost entirely hand-held, but the decisions to do so were made specifically because the resulting film would be unsettling. And even then, the cinematographers had to take great care to keep the effect as subtle as possible.

The trick to good hand-held shooting is to avoid elaborate movements altogether. Don't be tempted to run around with the camcorder as if you are trying to shoot an episode of *ER* – that programme is shot under very controlled conditions, and its camera operators are extremely experienced and talented. Keep your arms close to your sides, with your elbows tucked right in at the waist. Use your waist and hips to turn the camera rather than your arms. If the shot allows it, keep the lens wide, so as to minimize camera shake. If you must walk with the camera, keep your knees soft, and try not to bounce with each step. Possibly the best advantage of hand-held shooting is that it allows you to reposition the camera quickly and easily, moving from eye-level to low-level shots or swinging quickly from one subject to another. Changing position between shots is possibly the best use of hand-held shooting, however. Trying to emulate the more controlled movements of tracks and jibs with a purely hand-held set-up can leave you with very amateurish footage.

Steadicams and Other Stabilizers

Tracks and dollies take time to set up, require extra crewmembers and apply restrictions to composition, as you are always trying to ensure that the tracks are kept out of shot. On the other hand, working hand-held saves time, keeps the crew small and allows greater

freedom of composition, but gives your movie a rather uneasy, voyeuristic feel that may not be appropriate to the subject matter. Movie makers are always on the lookout for a compromise between the two shooting methods, and in the professional marketplace that compromise is called Steadicam.

Steadicam was devised for big-budget movie productions and was first used to its fullest on Stanley Kubrick's adaptation of *The Shining*. The device is a carefully balanced and articulated arm, supported by a body harness worn by the operator. The camera is placed on the end of the arm, where it 'floats', unaffected by most of the physical factors that create camera shake. Because the operator does not touch the camera directly, a small video monitor is also provided on the Steadicam rig, so that you can see what you are shooting. The appearance of small digital camcorders has given rise to a new breed of Steadicam, from full small-scale rigs for the prosumer to much more basic hand-held set-ups for very light-weight camcorders. They all work

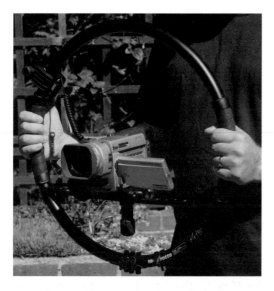

The Fig Rig.

on the same principle of providing a pivoted spindle support on which the camcorder can balance. They're not all made by Steadicam or its parent company, Tiffin. Many different companies have got in on the act to produce smaller and cheaper alternatives, which vary in quality and performance, and can't be officially called Steadicam – just as Walkman music players are made exclusively by Sony, iPods are made by Apple, and Hoovers are made only by Hoover.

Even Steadicam isn't a perfect solution, though. As much as it does a good job of eliminating camera shake and smoothing out actions that would otherwise be awkward when working hand-held, they still don't come close to the smooth, controlled nature of a slow track. Steadicams can take a while to master, too – being a Steadicam operator is a bit like being a puppeteer. It takes skill and practice to make the camera fly rather than yawn and shuffle. Steadicam shooting also gives limited control over the shot itself. With both hands on the rig and no remote controls, there's no way to adjust focus or zoom mid-shot. For that reason, most Steadicam shoots are done with a wide lens to catch all the action and maintain a large depth of field.

Stepping away from all the Steadicams and wannabes, acclaimed film director Mike Figgis has developed a different approach to camera stabi-lization. The design was adapted, built and marketed by Manfrotto under the unfortunate name of the 'Fig Rig'. The Fig Rig resembles a large steering wheel, with a camcorder braced securely in the centre. There are hand grips left and right, as well as clips around the perimeter into which additional microphones and lights can be mounted. The Fig Rig is designed cspecially for lightweight digital cam-corders, and costs less than many Steadicam clones. It has the same limitations concerning lack of manual control, but that problem is overcome by adding a Lanc controller to the hand grip, as seen in the photograph. The Fig Rig offers a neat solution that is well worth investigating.

Taking a big step back in terms of design and engineering, it is worth mentioning that a simple shoulder brace can do wonders for your video. Braces transfer much of the camera's weight to your shoulder, as it would be if you were using a big broadcast camera. They minimize wobble in normal operation and help prevent the lens from dipping if you start getting tired. Shoulder braces can sometimes be as expensive as Steadicams, but they're arguably much more versatile and allow more hands-on control of the camcorder itself. They also seem to pop up regularly on internet auction sites such as eBay.

PREPARATION – STORYBOARDS AND SHOOTING SCRIPTS

The best thing you can do to get a shoot moving smoothly is to plan ahead. Know what you want to shoot and how you plan to shoot it. You will always find yourself adapting plans on the day to overcome hurdles or to take advantage of unexpected opportunities, but a thorough game plan will at least help ensure that you know what you need to collect as a bare minimum.

For dramas and corporate productions, the first plan to be created is a script or screenplay. Scripts provide dialogue and voice-overs as well as conveying the flow of events. They rarely contain information on camera angles or other technical details unless these are absolutely essential to the sense and flow of the narrative.

If you are planning to sell a screenplay, or present it to people in the hope of raising money for production, be aware that investors will expect your work to adhere to a specific layout style. This formatting makes scripts easy to read – especially if you are in the business of reading a lot of them. For a start, ensure that the script is printed on only one side of the page – don't use both sides, even if it

A shoulder brace is technically less impressive than a Steadicam but can help achieve good results.

is the environmentally responsible thing to do. Double spacing helps legibility, and leaving good margins allows cast, crew and investors to scribble notes. From an aesthetic standpoint, aim to have more empty white space on the page than black ink – it will be less daunting for those you present it to. Each new scene should begin with emboldened and capitalized notation informing the reader whether the scene takes place in an interior (INT) or and exterior (EXT), what the location is and whether it is night or day. An example might be:

```
INT. PETE'S OFFICE – NIGHT
```

These introductory notations should be justified to the left of the page, as should action notes, describing what characters

67

are doing. Dialogue, on the other hand, is confined to a narrow column in the centre of the page.

> PETE
> Your dialogue would look something like this and should stand out from other text on the page, making it easy for actors to skim through. Remember always to keep the character names in capitals, as well.

Other information that can go into a script includes transitions such as FADE IN or FADE TO BLACK. For these initial stages, however, keep it simple and don't let anything get in the way of the story. The people you invite to read the script should get sucked into the narrative, not sidetracked with descriptions of shots, camera movements or lighting decisions.

Once production starts in earnest, break this script into smaller chunks and start working out your shots. The simplest way to start is to 'tramline' the script you already have. With a pencil and ruler, mark lines through the script to represent different types of shot: be they long shots, medium shots or close-ups. Don't be afraid to overlap areas – the purpose of marking up pages is to give us a shooting guide, and overlapping the shooting decisions allows us more flexibility in the edit suite. You might, for example, want to shoot a long shot of the whole scene for safety, but be more specific over where close-ups and medium shots should fall.

You might feel that tramlines are all that are needed to guide you through the shoot, especially if you are working with a small cast, a tiny crew and a location that doesn't

offer much in the way of control. For many productions, however, a storyboard is considered a necessity, too, illustrating each shot with a sketch similar to a comic book story. Camera movements can be represented, and key actions or dialogue are written as captions beneath each image. It doesn't matter if you are a good artist – the simple process of creating a storyboard will force you to think even more about the shots, making decisions that would not ordinarily offer themselves up when tramlining a script. A shot list can also be created, listing each shot with technical notes that might not make it into either the tramlines or storyboard.

Documentaries and event videos don't follow as rigid a script as dramas; however, preparation can be even more crucial, considering that you may not get the opportunity to re-shoot events if you miss them first time round! Never go into a shoot 'blind': try to get a sense of what is going to happen before you turn up to record the

A tramlined script.

SHOT	TYPE	DETAIL
SCENE 1:	**INT. PETE'S OFFICE – NIGHT**	
1	Wide	Establishing shot of author sitting at his computer, surrounded by a chaotic pile of paper, computers and books
2	Medium	Medium shot of Pete staring at computer monitor as he appears to type furiously
3	Close-up	Pete's fingers hammering the keyboard – they seem never to leave the cursor keys, however
4	Close-up	The computer screen. A Word document is open with a half finished chapter displayed. On top of that, however, is an active game of Tetris
5	Cutaway	Detail shot of office junk – a pile of test prints for a DVD cover that haven't been binned yet
6	Cutaway	The answer phone is blinking and has not been listened to for ages
7	Cutaway	A stack of loose hard drives

Sample shot list.

event. If this is a wedding shoot, get a sense of the location, as well as a clear idea of what kind of ceremony it will be, and how events are expected to unfold. Know where you can and cannot place cameras, and from which direction the light will be coming at the time of the ceremony. Also have a checklist – physical or mental – of all the key events that need to be covered (such as the arrival of the bride and close-ups of the exchange of rings). Every event works to a script of some description, so follow it as closely as possible.

We'll be covering these issues and more real-world scenarios in Chapter 6.

A storyboard.

5 CREATIVE CONSIDERATIONS

Having learned how to use a camcorder in a measured and controlled manner, it is time to apply those techniques to creative movie-making. How you frame a particular shot can have an immense impact on the way in which the audience reads it. Framing, the pace of editing and the use of colour, perspective and depth of field all help to influence the emotive quality of video, and can do as much to convey a sense of mood as the subject itself. Motion pictures have a language of their own – one that has become quite complex over the last century.

FRAMING VIDEO

How are the elements within a shot going to be arranged? There's often a lot more to consider than whether or not the main subject is visible. There are props, foreground and background objects that we might want to include, and microphones or crew members that need to be excluded. When shooting 'on the hoof' for event videos, many of the framing decisions you make will be instinctive and, for the most part, if a composition looks right, it is right. Practising more controlled techniques is still

Be aware that in every video image an approximate 10 per cent border will be cropped by most domestic TV sets. The remaining image is called the 'action-safe' area. Giving subjects some headroom will help ensure they're not cropped too closely.

Give subjects room ahead of them in the frame into which to look.

A simple composition demonstrating the rule of thirds: notice how horizon and eyelines all fall on the divisions.

worthwhile, however, regardless of whether the bulk of your work will be drama, corporate video or weddings, as they will help you build a more advanced visual vocabulary and create much more persuasive movies.

At the most basic level, a simple set of rules for framing people will allow novices to create useful editable video, and also provide a mental checklist for event videographers who need to find a good shot quickly. Whether framing a person in a long shot, medium shot or close-up, try to avoid cutting them off at joints such as knees, waist or neck. Also ensure that subjects are given a little headroom to compensate for the fact that TV sets have a habit of cropping into video images by about 10 per cent. If your subject is talking to someone off-camera – or even just looking off-camera – give them plenty of space in the frame into which to look: don't have their faces squashed up against the side of the frame. The same goes for action: if you are panning or tracking with a moving subject, leave plenty of space in the frame ahead of them.

Dividing the Frame

Just as typographic designers use grids to guide the layout of pages, so good composition for video depends on how the frame is divided. A symmetrical frame can sometimes yield very striking and imposing results, and can make for impressive establishing shots, particularly in more stylised productions such as adverts or corporate videos. But in many cases, the most interesting compositions are to be had from an asymmetrical frame.

A simple and commonly used approach to asymmetrical framing is to use the 'rule of thirds'. Divide your frame into three equal portions, horizontally and vertically, resulting in nine segments, and then align objects with the four bisecting lines. Use any of the inter-sections to place key elements of the frame, remembering that non-physical elements such as the vanishing point of parallel lines (i.e. the point where they appear to meet) can be just as important as people and objects. In many cases, viewers are instinctively drawn to the top right of the central block, making it a good place for the main subject or for any subtle details that you

71

Here, the car's rear-view mirror provides an effective frame-within-a-frame.

the camera can help lead the viewer into the frame, define what's important, and also give a greater sense of depth to the image. In old B-movie Westerns, some directors and cinematographers were known for habitually placing wagon wheels in front of their cameras to add interest to shots when low budgets and rushed production schedules didn't allow for anything more controlled or creative. Using foreground objects in this way creates a 'frame within a frame', helping to isolate or emphasize the subject. It can also make more of a feature of the scene's context and setting. Typical examples are door or window frames, fences and foliage, but each setting will present its own options – just keep your eyes open for opportunities.

Foreground frames needn't be in sharp focus – as they are not the actual subject of the shot, they can be soft almost to the point of being abstract. In fact, keeping them even slightly out of focus can be a good idea in order to differentiate between foreground and subject, avoiding too much detail and distraction in the frame. Be aware too, however, that some frames might introduce an element of subjectivity or even voyeurism to a scene – particularly if you choose frames such as windows or keyholes!

don't want your viewers to miss. In addition, use these guidelines to place horizontal and vertical divisions, such as the horizon or door frames. They should also be used as a guide for positioning the eyes of human and animal subjects. If the shot is going to involve a camera move, think about how it will be composed at start and end of the movement, to ensure that it appears balanced throughout.

This rule of thirds is a very useful guide to help ensure an interesting and balanced composition, but is not the only way of dividing up a frame. Take some time with a pencil and ruler, drawing lines through a rectangle. With only two bisecting lines, you can create a variety of sub-frames with varying shapes and sizes: some square, some long and narrow. Experiment with diagonals, too. Spend some time examining photos, movies and magazines to see examples of how frames and pages are divided. Pay particular attention to advertising, which is often the most bold and daring environment for visual design.

Foreground Framing

Frames are not always divided by imaginary lines. Placing objects between the subject and

Background Framing

For the most part, backgrounds are best kept simple so as not to overly confuse a video frame and distract the viewer from the subject. But some careful framing can make them instrumental in leading viewers' attention to specific details and generally emphasizing its action. In this way, backgrounds can be just as useful as foregrounds for framing subjects, and can give rise to some very subtle and persuasive compositions. Simple shapes created by arches, doorways or even high-rise buildings can create a frame in which to isolate a particular subject. Don't just look for

physical structures – examine the colour and tone of a background to find frames and divisions. Converging parallel lines or other diagonals such as walls, roads or rivers can be used to guide the viewer's attention into the frame and up to the subject. You may also find naturally occurring shapes that neatly echo the subject's own form.

As well as examining the background for details that can help the composition, keep an eye out for elements that can ruin it. In particular, remember that video is a two-dimensional medium, and it is very easy to lose a sense of depth, resulting in an odd fusion of foreground and background. Take care to examine the way in which subjects interact with each other in the frame.

DEPTH OF FIELD

Sometimes simply focusing on a subject isn't enough. You might also want foreground and background elements to be very obviously out of focus, or you might need the whole composition to be pin-sharp. The range of distance from the lens in which objects remain in focus is called the depth of field, and is

Do You Need a Background At All?

Some subjects are most striking when they fill the frame entirely. On examining different types of subject, you will probably find details or angles in which they neatly create an interesting composition without the need for background, foreground elements or props. The result might be a somewhat abstract image, but even these shots are worth seeking out, as they might help add interest to an edit later in the movie-making process.

affected by two key shooting decisions: aperture size and focal length.

If an image has a shallow depth of field, objects will become blurred very quickly as they stray from the focal point. This means that the subject will be sharp, while almost all other elements of the foreground and background will be soft. Shooting video of this type can be tricky, as extra care must be taken to keep focus where it is needed, but the results

Narrow depth of field can yield striking results and help separate subjects from backgrounds.

This image illustrates a large depth of field, in which almost everything in frame is sharp.

are often stunning, and add huge emphasis to the subject. A shallow depth of field is achieved by opening the iris wide, or by shooting on a very long lens zoomed in as far as you can go. ND filters can be useful when shooting in strong daylight, helping reduce incoming light and opening the iris further, but the main limitation for users of affordable camcorders is the size of the machine's CCD. The larger a camcorder's CCD, the shallower your depth of field can be. Broadcast cameras with chips measuring 1in in diameter will be capable of much smaller depth of field than a domestic machine with a ⅓in CCD. That's not to say that consumer camcorders keep everything in focus at all times, rather that a shallow depth of field is not nearly as easy to create and manipulate.

At the other end of the scale, a large depth of field keeps more of the image in focus. Foreground and background objects remain sharp, as well as the actual subject. If the background is busy, this might serve to confuse the image, but it also makes shooting easy – especially for documentary work where anything can happen. It is also a necessary compromise when using many Steadicam-type stabilizers, as manual focus controls are generally unavailable during operation. Depth of field is increased by reducing the size of the camcorder's iris, and by reducing the focal length, making the lens as 'wide-angle' as possible. Adding a wide-angle adapter will help matters further.

FOCUS PULLING

If an image has a very shallow depth of field, you will be able to shift focus between objects at different distances from the camera – a process known as focus pulling. Focus pulls are very effective and make a good alternative to cutting between shots. You will see them used in most mainstream movies, as a way of guiding the viewer's attention between two or more subjects in a single frame. On a more subtle level, focus pulls can be used to keep subjects in sharp focus as they approach the camera or exit into the distance. In all cases, however, a good deal of precision is required to keep the effect smooth and simple. On professional drama shoots, cameras are equipped with expensive lenses, with focus rings calibrated according to distance. The camera operator (or, in many cases, a dedicated focus puller) can place markers on the lens during rehearsal to ensure they hit the right mark at the right time without having to make subjective decisions based on how things look in the viewfinder.

A focus pull between two chess pieces, aided by a very narrow depth of field.

Bringing the camera close to a subject and keeping the lens wide helps emphasise perspective.

Shooting from further away on a long lens serves to crush perspective within a shot.

On domestic and prosumer camcorders, however, there are no such calibrations on the lens, and the focus ring (if indeed it has one) will keep turning forever even if you've reached the extreme end of its focal range – making it impossible to mark up. Focus pulls on these machines can only be done by eye and by careful estimation of the limited manual controls. With some practice, you can achieve good results, but be prepared for a lot of trial and error. It is a worthwhile pursuit for dramas and corporate videos, but something to avoid for documentary-based work where you may only have one chance to get a particular shot.

FOCAL LENGTH AND PERSPECTIVE

As well as affecting depth of field, focal length has a dramatic effect on the perspective in an image. A shot taken at close range with a very wide-angle lens will be seen to have a very deep and dramatic perspective in which objects quickly increase in size as they approach the camera. Some big-name Hollywood stars have specific details written into their contracts concerning how close a camera can get to them, and with what focal length, as wide-angle lenses can create a 'fishbowl' effect,

distorting features and making noses appear massive. On a more generally practical level, wide-angle lenses help create a sense of open space and can exaggerate distance.

At the other end of the zoom range, shooting from a distance on a very long lens yields a much different image, in which subjects feel squashed together, and there is much less difference in scale between close and distant objects. Shooting a crowd scene in this manner will give almost unbearably claustrophobic results, and the approach can be a good one for downplaying motion – shooting a long-distance runner in this way as he approaches the camera will highlight the fact that he has a long way to go as he sweats and toils but appears to make little headway within the frame.

If you have access to a set of tracks, try zooming in on a subject as you physically track the camera away from them, all the while trying to keep the subject at the same size and position on the frame. The result is a very oppressive and stomach-turning effect as the background seems to close in around you. The technique was used in Hitchcock's movie *Vertigo*, and later more famously in Steven Spielberg's *Jaws*, before becoming one of the

75

Focal Length and Camera Shake

A long lens zoomed right in to a subject might accentuate depth of field and help to crush perspective, but it will also amplify any and all camera movements. If you are shooting hand-held, this makes camera shake a very big issue. If you are likely to be working much at this extreme of the zoom range, be sensible and use a tripod, taking care to lock and release the pan and tilt head without causing too much judder. Similarly, the wider the lens, the more camera shake goes unnoticed, making wide-angle work ideal for hand-held shooting. It is also recommended for work with stabilizers, smoothing over any stray bumps, while also taking advantage of increased depth of field to ensure that your subjects are kept sharp at all times.

most badly overused clichés of the last thirty years. This isn't a trick to impress people with, but it is fun to try for your own entertainment at least once!

OVER AND UNDEREXPOSURE

Depending on the effect you want to create, there can be a good case for overexposure and underexposure. In high-contrast environments, a slight underexposure will help yield a rich and moody image, as shadow detail falls away into solid blacks. Doing this can help lose the solidity of a subject's form – a technique that has served many monster movies well, forcing viewers to make up lost detail with scary stuff from their own imaginations!

Just as subtle underexposure can drain shadow detail from a shot, so a careful overexposure can bleach detail from highlights. Overexposing in low-contrast settings can hide blemishes and wrinkles in the subject's skin. The overall tone will also become more cartoon-like, lending itself well to commercials, corporate video, title sequences or the more stylized side of drama. Moving away from human-based subjects, playing with exposure when shooting abstract forms can be a fun exercise for creating textures for montage sequences and DVD menus.

A slight underexposure in high-contrast situations helps to create a more moody image.

Overexposure can be useful in evoking a more crisp, almost dreamlike mood.

SHUTTER SPEED AND MOTION BLUR

In many cases, you might not feel the need to play with a camcorder's shutter speed, but jobs such as sporting events can require some special treatment. As we saw in Chapter 3, increasing shutter speed reduces the length of time that light is exposed to the CCD for any given frame. In extreme cases it can give rise to slightly jerky motion, but it also has the advantage of reducing motion blur – an important consideration when you are dealing with fast-moving subjects, or when working hand-held on a long lens, where any camera shake can result in a blurry image. Reducing shutter speed increases motion blur, which can be used for effect, as in the example shown on page 46, using very fast and very slow shutter speeds to shoot a scene with flowing water. With shutter speed at its fastest, water droplets appear solid and static in the frame, while at the slowest setting, the water as a whole is soft and formless while the rest of the static scene appears sharp.

Slight motion blur is acceptable for most shoots, as video runs at 25 or 30 frames per second, and viewers won't be left to dwell on any particular frame. If you plan to slow footage down at the edit stage, different rules might apply. Frames will be left on the screen longer, making blur far more evident than it would be at normal speed. If you are shooting for slow motion, increase the shutter speed slightly to compensate.

CONFRONTATIONAL AND PASSIVE PHOTOGRAPHY

The camera's vantage point has a substantial influence on how viewers read a scene and the impression they have of the subject, and one of the biggest factors to consider is camera height. Shooting at the subject's eye level can be an easy way of making the audience engage with characters, and can make a world of difference when working with children as you are shooting the world from their perspective. Eye-level shots can be confrontational at times, however, but in the worst cases, they can be just plain boring. Moving the camera to a different height adds interest but says different things about the characters. Shooting below the subject's eye level makes them more imposing in the frame and gives them a sense of importance, while looking down on the subject makes them appear more passive or submissive. It is a technique that was used extensively in Orson Welles' classic movie *Citizen Kane*, in which strong characters such as Charles Kane are shot from below, and weaker figures such as Susan are always shot from above. Welles reportedly adopted the approach from John Ford's *Stagecoach*, made two years previously.

Just as shooting at a subject's eye level can be confrontational, so can meeting their eyeline. If a character on screen looks directly into the camera lens, they are effectively

High shutter speeds are useful in keeping high-action scenes sharp, but may result in slightly jerky motion and reduced depth of field as the iris opens to compensate.

Facing a subject straight on can be intimidating and confrontational.

Shooting from below makes the subject imposing in the frame.

Shooting from above can present subjects in a much more passive way.

Shooting children from their level helps bring viewers into their world.

making eye contact with the viewer, and that's something that almost never happens in dramas and many documentaries. Movie makers try where possible to keep a sense of separation between the audience and the action on screen. Viewers are observers or voyeurs and they never – or very rarely ever – engage with the characters they are watching.

Oliver Hardy was known to gaze into the camera at comic moments, almost in an attempt to solicit sympathy from the audience, and some movies – such as *Alfie* and *Wayne's World* – have their main characters talking directly into the camera, but these are rare techniques in cinema, and the majority of film makers opt to keep audience and characters separated at all times. The closer a camera comes to a subject's eyeline, the closer we are to making that connection with the viewer. Facing the subject straight-on creates a sense of confrontation, while shooting a profile shot is more passive and creates less tension for the viewer. Either approach can work in your favour when planning and shooting a scene, but be aware of the effect that camera placement will have on the viewer.

EXTREME LIGHTING

Good use of lighting can elevate video from the amateur level and give the appearance of a polished production. But it doesn't necessarily need to look natural. Abstract projects such as commercials, music videos and even some corporate projects can benefit from lighting that bears no resemblance to real life and makes no attempt to emulate natural sources. An easy, and somewhat clichéd, first example is the underlighting of a subject's face. In the real world, we are used to light sources coming from above. When that's changed, and the key light is placed below the subject's chin, the result can be unsettling. It is a technique that has been overdone in many horror movies to a point where campers telling ghost stories round a campfire often feel the need to shine a torch up into their faces just for the effect...

In old black-and-white movies, narrow bands of light were often cast across the eyes of actors to emphasis them. The technique has largely been abandoned today, but still makes the occasional comeback in stylised gothic movies. Barry Sonnenfeld's *Addams Family* movies always seemed to have Morticia's eyes highlighted in this way. By comparison, however, Steven Spielberg's black-and-white Holocaust epic, *Schindler's List*, used the same technique but made a deliberate effort to miss the actors' eyes. The effect that was both stylized and unsettling in that we knew that things were not as they should be at a very fundamental level.

Going further, however, using coloured gels on lights can significantly alter the tone and mood of a scene, and the stronger a colour becomes, the more stylized its effect will be. In very extreme cases, you can swamp the entire scene with one particular colour, working within a specific context (such as a photographic darkroom where only red light is allowed) or just playing for effect.

The uplit face created by the use of underlighting– one of cinema's biggest clichés.

The effect of light needn't just be seen in reflection either. In a smoky, misty or dusty atmosphere, you will see shafts of light cutting through the air. The effect has been used to give solidity to car headlights, the floodlights on 20th Century Fox's logo, and in Westerns and thrillers to emphasis the effect of bullet holes, allowing light to flood into dark hideouts. Shafts of light coming in through the windows of old buildings and ceremonial halls can greatly enhance atmosphere, and the

Isolated bands of light used to highlight details such as eyes – another common practice from the early days of cinema.

79

Lighting with excessive use of coloured gels helps to create an unnatural, stylized colour effect.

effect isn't restricted to interiors – sunlight cutting through clouds can have a similar effect. Keep your eyes peeled and be ready to adapt your plan when opportunities present themselves.

There is no law to say that your subject must be the item in frame that is correctly exposed. Setting subjects against bright backgrounds and presenting them as silhouettes

can yield good dramatic effects. In exterior locations, there are plenty of opportunities for this. Car headlights, neon signs, shop windows and other street illuminations provide excellent backdrops for moody, silhouetted images.

Flashing lights are also good for enhancing drama, building tension in scary moments or enhancing the beat of music videos. There are a few issues to be aware of when shooting strobe effects, though. Most important is the fact that strobe lighting and flashing imagery can badly affect viewers with photosensitive epilepsy. Many video makers avoid strobes altogether for that reason alone, but if your movie is going to use flashing lights it might be in everyone's best interest to post a warning at the beginning so viewers can decide in advance whether or not to watch. Another concern with strobe lighting is to ensure that the effect isn't ruined by the camcorder's shutter speed. If the strobe is out of sync with the camcorder's shutter, you could end up with an odd striping effect on the final image, or the strobe itself might appear more random and erratic than it was in real life. To avoid this

A large spider crab can appear intimidating when well lit, but can be absolutely terrifying when allowed to loom out of the gloom in silhouette. Notice too how condensation on the glass of the tank obscures the form even further.

problem, keep the frequency of flashes fairly slow and their length fairly long – four to six per second or fewer should be fine. The faster you crank the strobe, the more problems you are likely to see.

USING TEXTURE AND REFLECTION

For the most part, your priorities will be to gather clear, crisp, interesting footage – any crazy, distorted effects can be created later when the material is edited. Some settings invite a departure from this rule, however. Reflective surfaces and textured glass provide opportunities to take a more abstract and design-orientated approach to shooting. You wouldn't want to shoot an entire scene in this way, but abstract shots can serve well to introduce a new scene, making a nice alternative to simple, wide establishing shots.

Landscapes featuring lakes or rivers lend themselves to lovely shots, with buildings reflected in the surface or perhaps giving the illusion of a patch of sky in the ground. Moving in slightly, we might opt to shoot only the reflection itself, creating intriguing effect as ripples move across the surface. Highly polished metal surfaces and the mirror glass

Extreme Colour

On a technical level, it should be remembered that most affordable video formats prefer the blue and green end of the colour spectrum to the red end. Domestic analogue formats are very prone to colour bleeding when bright reds are used excessively – the colour seems to spread out of its confines like ink on blotting paper. While bleed isn't such a big problem for digital formats such as MiniDV, strong reds should still be treated with caution, as the CCDs of domestic camcorders are designed to be more sensitive to blues and greens than they are to reds. When working with bright and garish subjects, a single-CCD camcorder is likely to give intense blues, greens and purples, but slightly muted and dull reds. Also, as most of the image detail is carried and processed in the picture's green channel, excessive reds can significantly compromise detail, too. A green-dominated image will appear brighter, crisper and more detailed by comparison.

Don't let that put you off playing with strong, bold colours though. Some striking visuals have been achieved in cinema by dressing sets and actors in different shades of a single colour – superb examples can be seen in Zhang Yimou's action movies *Hero* and *House of Flying Daggers*. Also, Hollywood musicals from the 1940s and early 1950s illustrate some stunning uses of colour design and photography, which was encouraged by the very saturated tones of three-strip Technicolor film being used at that time.

By contrast, makers of dark and gritty thrillers or horror movies are now prone to use less colour rather than more. Movies such as David Fincher's *Se7en* used a film-processing technique called Bleach Bypass that gives very high contrast and low colour saturation, all helping to evoke a very dark and oppressive feel.

Beyond the need to set an overall tone for your movie, colour can also serve to emphasize subjects and guide them through a scene. Viewers are instinctively drawn to the brightest and most colourful parts of an image, so brightly coloured objects in an otherwise muted scene can act as a beacon, pulling viewers in and pointing them in the direction you want them to look. The subject itself can be the brightly coloured element, or you can use colour as a pointer – with yellow lines at the side of a road, for example.

Reflective surfaces can create interesting composition opportunities, such as mirroring the shape of this bridge in Durham.

common in new office buildings provide more opportunities for reflected shots. More challenging – but potentially more interesting – is the effect of shooting through windows, catching the subject on the other side as well as anything that is reflected in the glass. Such a shot might leave you with some dilemmas regarding focus (on the far side or on the reflection?), but that's one instance where focus pulls can become incredibly dramatic.

Shooting subjects through transparent surfaces adds an interesting abstraction to the shot.

LENS FILTERS

Lens filters fit to the front of the camera to alter the nature of incoming light for practical purposes or aesthetic effects. On an aesthetic level, many filter effects can be simulated in the edit stage, but the process could leave you waiting a very long time for the video footage to render (editing programs need to recreate footage with special effects applied). One filter that is often recommended for all jobs is a basic UV filter – primarily because in digital camcorders it has almost no effect on the image you're shooting. It can be left on the lens at all times, helping protect the glass against accidental scratches and smears. As we have already discussed in an earlier chapter, Neutral Density (ND) filters are great for evenly absorbing incoming light so as to take advantage of wider apertures for depth-of-field control, or simply preventing the need for overly high shutter speeds in very brightly lit environments.

Of the more adventurous filters, one that is very useful and which cannot be easily reproduced in post-production is the polarizing filter. Polarizers limit the incoming light to waves that travel along a specific plane and, as a result, effectively eliminate glare from bright surfaces such as water or snowscapes. This in turn recovers detail that would otherwise be lost and enhances colour saturation. A huge bonus is the way in which these filters affect skies – adding definition to cloud that is ordinarily lost in normal shooting. They are useful, too, when shooting subjects through a window, as they can remove unwanted reflection. The filters are composed of two rings that rotate, allowing you to choose the plane along which light will be polarized.

Polarizing filters have their compromises, though. Firstly, they reduce the amount of light coming in through the lens, requiring a wider aperture to compensate. Secondly,

they can interfere with autofocus. Linear polarizsing filters leave light polarized when it enters the camera, which can affect performance of many of its internal sensors and automatic controls. Circular polarizers overcome this problem by effectively 'depolarizing' light on the other side of the filter. Therefore, a circular polarizing filter works better with autofocus cameras than a linear one, but users should be ready to shoot manually regardless of which type they choose.

Lens filters can be an invaluable part of your toolkit.

Filters used for purely aesthetic effect start with simple colour tints. There are sepia tones and tobacco filters, which apply a somewhat aged feel to the footage, and there are also 'enhancing' filters that accentuate colours at one end of the spectrum, such as reds and oranges, while leaving others unaffected. There are also graduated that which provide a coloured tint to the top of the frame, fading to a clear bottom – used for darkening skylines to extract cloud detail and help create a more atmospheric shot.

Stepping away from simple colour tints we find diffusion filters, which soften the picture in different ways. A simple diffuser will scatter light rays to remove hard edges and lose detail such as skin blemishes. The effect can be a little sickly, however, and can leave viewers wondering whether the camera was just badly focused. Black diffusion and Pro Mist filters do a more pleasing job, reducing contrast and softening hard edges, but still maintaining a good clear picture. Some diffusion filters can also be bought with clear spots, allowing a subject or detail to be untreated, while the rest of the frame gradually loses detail, providing a nice subtle emphasis.

Other filters are used to simply increase or decrease contrast to compensate for difficult shooting conditions or to create a specific mood. A final filter type is the star filter, which emphasizes bright highlights such as candle flames or car headlights, giving them a large

star shape. Different filters give stars of different shapes; it is an extreme effect, but a nice one for stylised productions such as corporate or wedding videos.

When buying a filter, be sure you get the right size for your camcorder: the filter diameter will be printed either on the lens barrel itself or in the camcorder's manual. If you cannot find one that fits, step-up rings are

A polarizing filter is a great help for reducing reflections when shooting through glass surfaces such as this aquarium tank.

available, which allow larger filters to be fitted to smaller cameras.

Lastly on the subject of filters, be aware that most filter effects cannot be removed from video if you later decide that you don't like them. If in doubt, work without and add a similar effect later at the edit stage. If, however, you are clear about what you want and know for sure that a specific filter will do the job, go for it – you will save yourself many hours of rendering in post-production!

SHOOTING FOR THE EDIT

Unlike stills photography, individual video shots aren't designed to stand alone as a single exhibit. There are exceptions, of course: Aleksandr Sokurov's *Russian Ark* is a 96-minute drama composed of only one continuous shot, Alfred Hitchcock's *Rope* was composed of long unbroken shots lasting between four and ten minutes (ten minutes being the maximum length of a single reel of film at that time), and the first ten minutes of Orson Welles' *Touch of Evil* was shot in one continuous take. These are very rare examples though, and most movie makers collect footage with the intention of using multiple shots in sequence.

Cutting between shots makes shooting easier as action can be broken down into manageable chunks (rumour has it that Hitchcock had to re-shoot the last few segments of *Rope* because he didn't like the colour of the sunset). It also gives the director and editor more control over the viewer, guiding their attention, and also shortening sequences that drag on too long. Editing dictates the pace of a movie, too. But for all its advantages, editing needs to be invisible. Audiences shouldn't be too aware of a change in shot. They should read your edited sequence as a single event happening in real time, rather than the reality of a combination of shots that

could have been collected days apart. To achieve a seamless edit, care and consideration must be taken during the shoot.

Reaction Shots

Drama is just as much about reaction as it is about action. And whether that drama is a fictional narrative or an engaging documentary, it is essential to show how people and things are affected by a subject's words or actions. Even a simple interview benefits from the showing reactions of the interviewers: are they getting bored? frustrated with a monosyllabic subject? or maybe struggling to get a word in edgeways? Showing how people respond within a scene helps create more dynamic between characters and ultimately makes the overall narrative more credible. At the most basic level in interviews and dialogues, it is common practice to take a main shot and a 'reverse', each looking over the shoulder of one subject and into the face of the other. It is also useful to shoot single close-ups of each character – not just for their delivery of lines, but for their reactions too.

Reactions shots have a nice dual purpose in the edit. Not only do they help add an emotional context to a scene, but they help patch over technical hiccups and fluffed lines. If the subject moves out of shot and the camera has to be adjusted to compensate, inserting a reaction shot will hide the move. If lines are forgotten and you need to change to a different take, inserting a reaction shot will make the change seamless. Similarly, in an interview set-up, if a line of questioning goes nowhere and results in awkward silences or 'ums' and 'ahs', slipping in a reaction shot can allow you to trim the main footage without the audience noticing any cuts.

In drama being shot with a single camera, you would work reaction shots into the normal schedule and shoot them alongside the rest of

the footage for the scene. Interviews can be trickier, especially when your time with the subject is limited and you only have one shot at each question. In the absence of a multi-camera set-up, many video journalists keep their camera on the subject, then turn it on themselves long after the interview has finished to re-record their questions as well as some 'noddy' reactions.

Cutaways

Cutaways are illustrative close-up shots that help provide focus for a sequence. They can be close-ups of key props in a scene, or detailed view of actions such as a cigarette being lit, a CD being placed in a hi-fi system or a coin being dropped in a slot machine. Cutaways help to clarify what people are doing, and provide more visual action to a scene that could otherwise become too dialogue-heavy. But, like reaction shots, they also provide useful patches for rescuing scenes from wobbly camera moves and fluffed lines, as well as providing cover should a scene need to be substantially shortened in the edit. Big-budget productions employ dedicated 'second unit' crews to pick up material like this, leaving the main crew to concentrate on the core storytelling. In smaller productions, you will often find the crew assembled over weekends without the principal cast simply to shoot cutaways – the hands playing that piano don't necessarily have to belong to the actor used elsewhere in the scene. Collect cutaway shots wherever and whenever possible. They might not all get used in the final edit, but you never

Continuity

How many times have you seen a movie in which a character is smoking a cigarette in one shot, but is empty-handed in the next? Or where the level of beer in a glass jumps up and down as we move between camera angles in a pub scene. There are too many TV programmes to list in which actors' ties change colour or jackets magically disappear. These are all examples of bad continuity, and they can affect any production regardless of budget.

One way to keep continuity problems in check is to be very cautious about consumable props. Cigarettes get shorter over time, glasses get emptier as people continue to drink from them, and cakes have a strange habit of disappearing. If you must use items like this in a scene, be prudent. Have a smoking subject light a new cigarette for each new take – it'll probably make them sick, but it serves them right for smoking in the first place! Similarly, refill glasses and plates for each take, and advise actors not to use the shoot as an all-you-can-eat buffet. Many good actors have the ability to act naturally with food and cutlery without actually eating a bite – such people are worth their weight in gold.

Things get more complicated when we start working with costumes, lighting and set dressing, and it is here where things need to be itemized and organized. Feature films and productions with decent budgets hire dedicated continuity staff to ensure that everything is as it should be from one shot to another. These people work with detailed notes on all elements of a shot, and are usually armed with Polaroid cameras and a clip full of instant photos showing set details and costumes. They might also shoot photos or video of the beginning and end of each take so they have an immediate reference to details such as whether a particular prop was held in the right or left hand, and whether a jacket was open or buttoned.

know when a little detail can help make sense of a scene or provide the cover necessary for a complete restructure.

Cutting Cues

Sometimes a scene's action, setting or potential camera movements provide opportunities for more creative cutting between shots. Foreground objects obscuring a frame provide fantastic cover for sly cutting between long, medium and close-up shots, or for switching angles completely. If the direction and perceived speed of the camera is kept constant, it will appear to pass behind an object such as a tree, pillar or person, and re-emerge on the other side with a different viewpoint. The effect can be a somewhat disorientating one, but sometimes that's exactly what you want! The technique has more subtle applications, however – people walking in front of the camera, or cars passing by in the foreground provide effective points at which to cut to another shot. In the case of controlled dramas and corporate productions, such cutting points can be planned, timed and stage-managed along with everything else.

Lead In and Lead Out

Think about how a new scene will be introduced. Sometimes it is sufficient just to drop the viewer in at the deep end of a tense situation, but other scenes might require some introduction and explanation. Either way, think about making a grand statement to signify that the time and setting have changed; to use a writing analogy, devise a shot that serves the same purpose as the capital letter at the beginning of a sentence or the line break before a new paragraph.

A very standard device is to start wide to establish your setting and them move in on the scene's various subjects. This is a good way to keep things clear and to organize ideas, but it is not always the best plan for making a dramatic entrance. Not all movies begin new scenes with a wide establishing shot – some begin with close-up details and cutaways, such as a DJ's turntable to signify that we're in a club, or technical details of a car being filled and fitted before a race.

Another approach is to use minor characters or objects to lead us into a bigger picture: Jacque Tati's *Mon Oncle* uses a pack of small dogs to lead us through the low-tech, rather shambolic town into the modern and clinically soulless environment that is the home of its main character, Gerard. The opening sequence of *Touch of Evil* uses a single unbroken shot to follow a variety of pedestrians and market stall vendors before finally settling on its main subject. For dramas, these devices can be scripted and storyboarded. If you're shooting documentary or event videos, keep your eyes open for opportunities that might lead you from one part of the video to another.

POINT OF VIEW – THE SUBJECT'S PERSPECTIVE

A good way to bring an audience into your narrative is to allow the audience to see through the eyes of your subject. Some movies are shot entirely from a single point of view, but those cases are very rare. A point-of-view shot makes a clear statement about the hurdles a character is facing. Overuse the device, however, and the movie becomes voyeuristic, such as the opening sequence of *Halloween* and the deluge of cheap slasher movies that followed. A neat device to bring a first-person perspective into movies without inviting the audience to 'be' a particular character is to use a movie within a movie, such as the camcorder footage used in *The Blair Witch Project*, which gave us the characters' point of view, but still maintained

A Brief Word About Paperwork

Admittedly this isn't particularly creative, and you are going to find the suggestion dull and boring – possibly even a distraction from your vibrant artistic plans – but good note-taking is a vital discipline when shooting video seriously. Think about all the work you are putting into each project, and then remember that it is all being committed to small MiniDV tapes, each one taking about an hour of footage. When the time comes to edit this material, you will have to capture and organize the clips you need for the final cut. Without a good set of notes taken at the time of the shoot, you will find yourself wading through hours and hours of tape trying to find the shots you need (and then spending time watching multiple takes to remind yourself which one was the best). And all that comes before you get down to the actual job of editing! Good notes on each shot, along with carefully

marked tapes, will cut hours (if not days) from your editing schedule. It may be a boring job to do, but you will be thankful you did it.

If you have been working to a tightly controlled script, list the scene and shot numbers as listed on the storyboard or shot list. Also, note the take number and comments on whether it was a good take, or whether there were technical or performance-related problems. Also make sure that your notes tell you which tape these shots are on. For documentaries shot on the hoof, keep notes on location, date, time and subject, along with the shots taken, technical notes and comments about the on-screen 'performance' and a reference to the tape used. Needless to say it is also essential that tapes be correctly labelled, and don't forget to pop the record-protect tab when a cassette is full to prevent accidental erasure.

a sense of detachment from the situation – arguably making the scenario even more voyeuristic than if we were there in the thick of the action.

Transitional Shots

Transitional shots act as a bridge from one scene to the next. They are often unnecessary if your scenes make strong enough entrances on their own, but they do come in useful in slowing the movie's pace and allowing the viewer to draw breath mid-movie. You will see transitional shots used extensively in TV drama – *CSI* punctuates scenes with sweeping

views of Las Vegas, while the more modestly budgeted sitcom *Cheers* simply used a static shot of the exterior of the Boston bar. These shots are short – seldom more than a few seconds in length – but are effective in spelling out to audiences that one scene is finished and we are about to start another. Another reason that these shots are seen so often on TV is that they also serve as filler shots for programmes that must be made to a very specific length. In your own work you might find them unnecessary, but it is worthwhile grabbing some exteriors and landscapes as you go, just in case they are needed.

What you shoot is entirely up to you when you're on holiday, and it is best not to let the process of capturing video get in the way of the holiday itself. Make it fun and keep it varied, capturing locations, people and general bustle. But remember that the movie is a secondary concern!

6 IN THE REAL WORLD

HOLIDAY VIDEOS

Since the dawn of home movie-making there have been holiday films and holiday videos. Holidays are one of the most common factors that drive people to buy camcorders, but the motivation doesn't always go as far as learning how to use it before embarking on the trip. Very often holidaymakers miss great shots because they are still getting used to their new toy, or they come out unprepared with insufficient battery power and end up carrying a dead lump of plastic and metal around with them for most of the trip. And then there is the litmus test of making other people watch what you've recorded. It might be asking too much for them to be gripped, enthralled and entertained, but it is only polite not to bore them senseless.

There are two conflicting agendas at play here: on one hand, you want to make a holiday video that will be watchable and do justice to all the fun and frolics you will be having along the way. On the other hand, this is your holiday, and you need to take it easy, relax and make time for all the fun and frolics that you have been planning. If you only experience your holiday through a camcorder's viewfinder, then it won't be a very successful holiday.

Some sensible shooting habits and a balanced approach to shooting will help you get the best of both worlds. To start with, travel light. Don't overload yourself with video gear. This isn't a commercial project, and your lighting, scenery and makeup don't need to be perfect. Your priority here is to get the best with whatever you can comfortably carry around with you. Modern MiniDV camcorders will slip comfortably into a jacket pocket, bum bag or backpack, along with a spare battery and a couple of tapes. At least one spare camcorder battery is essential, and it is good to get into a habit of recharging them at night. Tripods are cumbersome, but monopods are lighter and can even double as walking sticks on long hikes. Keep expensive electronics in your hand luggage, to make sure they are not damaged as big suitcases are flung one on top of another.

Hunt out a few useful lens filters in advance: ND filters for sunshine holidays, and polarizers if you plan to shoot around sand, snow or water. Wide-angle adapters will do wonders for your landscape shots, and for a personal job like this a cheap, lightweight adapter should be fine.

A directional microphone – even a small cheap one – is a great idea, and many have zoom controls to allow you to alter the extent of their directionality. Pack light headphones, too, so you can check from time to time that the mic is working as it should – if its battery dies, you'll be left with mute video!

A camcorder rain cover can fold up small when not in use, and can save you big money

on repairs if you are shooting around sand and salt water. Scuba housings always seem like a sexy idea, but they are big and heavy, occupy a lot of luggage space and won't get as much use as you might think. And then there is the fear of what happens if they crack or break. Big scuba resorts such as those on the Great Barrier Reef often have camcorder hire services – it is extra money, but not as much as buying your own scuba housing, and you won't be risking your own camcorder either!

As with any family recording, don't be afraid to pass the camera round. Everyone should be seen, and everyone should have their chance to capture the moments that interest them. If you have kids, and they are old enough, buy them a cheap camcorder of their own, and set them loose with it. If it gets damaged, they haven't broken yours – and you might be pleasantly amazed at the material they come back with.

Be determined to edit your video once you get home. Aim to collect good isolated shots – don't swing the camera wildly, trying to take everything in at once. I have seen many holiday makers simply walk around with their camcorders rolling, speaking a commentary into the built-in mic. When they come to watch back their tape, they will almost certainly be hit with a severe wave of seasickness and be unable to see exactly what it is they are talking about, as everything flashes by so frenetically. Take one detailed shot at a time, knowing that it can all be brought together later. Vary the types of shots used. Collect wide landscapes, medium shots and close-ups. Don't be afraid to set up or restage events with family or friends. If you miss a funny moment, it doesn't necessarily have to stay missed. Shooting cutaways is good practice, too, for tidying the final edit and establishing a bridge from one scene to the next. Commentating on what you are seeing is

a good idea, but aim to use that sound on its own later. Try some presenter work, too, being on screen rather than hidden away as a disembodied voice. Record some wild tracks too – you will be amazed how useful and effective they are later.

Don't be too proud to run the camcorder on automatic settings, but be aware of occasions when manual control is more appropriate, preventing unwanted focus shifts in crowds, or inappropriate exposure if you are shooting against the sun. Learn how to use the camcorder's Program AE modes to compensate for difficult lighting situations quickly and easily.

Make sure that something is happening in your video, and that people are actually doing something. You are in the realm of the moving image here, and it is not enough to simply have the family stand beside famous landmarks and smile inanely. If you want to do that, save yourself some money and buy a disposable stills camera rather than an expensive digital camcorder. Don't be afraid to catch candid footage – that is where the real honesty and excitement lies. Keep it casual, keep it honest and, above all else, keep it fun. There is no point in making a video of the holiday you would have enjoyed if you hadn't been so busy making a video!

EVENT VIDEOS – BIRTHDAY PARTIES

Unless children's party videos are part of your work repertoire and you are doing this as a paying job, it is inappropriate to worry too much about your kit for this kind of shoot. For a small home video, it is best to work with the kit you have, and try to get the most from it with sensible shooting techniques. I am already assuming you have got a digital camcorder and I am sure it will do the job fine. As with most video jobs, however, an

Take the time to capture fine details in close-up. Decorations won't look as good at the end of the party, and food has a habit of disappearing, so get in there quickly!

additional directional microphone will be a bonus for keeping the sound clean. A small lightweight tripod is a good idea, too, allowing you to keep shots steady when need be, and to either take a rest or take part in the fun and games without disturbing the shoot. Know how to adjust the tripod's legs, and how to mount and release the camcorder quickly, so you can be set up where you need to be in seconds rather than minutes. As we shall see later, a small video light can also be useful.

As with most events, kids' birthday parties work to a script. In this case, children are ushered through a timetable of fun and games that is set down in advance by the grown-ups. Sure, the stars of the show might ad-lib the dialogue, and some of the more creative ones might even change the ending, but you can be confident in the initial stages that there is a script and that it isn't written in crayon. Quite how packed that script is depends on who you are making this video for. If it is just for the

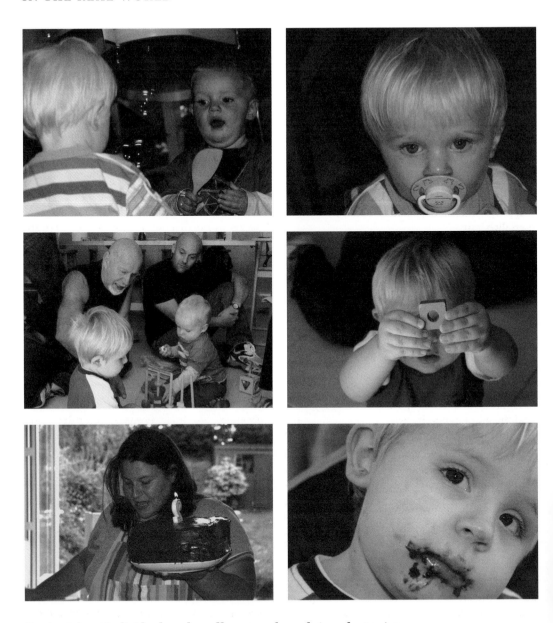

Try to pick out individuals and small groups of people in order to give the movie focus. Don't be afraid to hand the camcorder around so that you are in shot too.

kids, they will only be interested in the episodes that involve them – food, decoration, games and entertainment all just happen, after all. If it is going to be watched by other grown-ups and sent to friends and relatives who perhaps couldn't make it along on the day, you might want to include some representation of all the hard work and preparation that went into organizing this bash in the first place. If nothing else, you might like to get shots of the table spread, decorations and trimmings and trappings before the kids are allowed in to demolish it all.

A typical order of events for a party video might run as follows: preparation for the party, and a close survey of all mum and dad's handiwork before the guests arrive, the birthday boy/girl looking smart in his/her party outfit, guests arriving and being met and greeted by the little tyke who was trained in the art of party manners five minutes previously, opening presents, party games, entertainment (if a clown or magician has been hired), party food and the birthday cake, after-dinner games and the gradual goodbyes.

Don't plan to have every single moment of the party in the final cut. Shoot what you can, but keep in mind that you will be trimming all this footage down to its highlights when you start editing later. From the start, however, adopt a style for shooting and stick with it. This is a children's party, so it makes sense to shoot the whole thing from their perspective – perhaps even the preparation scenes for the beginning. When shooting inanimate details such as the food spread and decorations, go for a series of static shots rather than sweeping pans that can be difficult for viewers to make sense of. Remember too that children don't prioritize and organize their ideas the same way as adults – let them set the pace where possible. Keep shots running until their natural conclusions (you can always truncate them later) and don't submit to the temptation

of herding the kids through set hoops just to meet your plans.

Try to get all the kids on camera, and don't restrict your shots to the organized fun and games. How children interact with each other and with grown-ups is always entertaining, so seek out candid shots too. Get them talking to the camera as well – ask what they are enjoying and why. Children have a different perception of reality to adults, and so their comments can be a scream. As with holiday videos, make sure you don't hog the camera. You are as much a part of the day as any of the other adults, so make sure you have a shot at being on screen too. It is probably wise to delegate shooting to someone your own age, though – someone who doesn't have chocolate cake on their fingers and is less likely to leave the camcorder in a puddle of lemonade.

If entertainment such as a clown or magician has been booked for the party, then you face a bit of a tough challenge. On one hand, you want to shoot the act you have hired, but on the other, you need to record the audience's reactions, because that's the whole point of booking entertainment in the first place. If you have got two camcorders, the answer is simple: have one on the entertainer and another seeking reaction shots from the kids. If you are only working with one camera, things get a bit tougher. If you can, talk to the entertainer to find out what the biggest and showiest gags of the act will be, so you can try not to miss them. Otherwise, keep the camcorder rolling for the duration but plan not to include the whole act in the final cut. Keep the camera on the entertainer for one trick or gag, them swing round to the kids for the next. At the editing stage, you can bring reaction shots from one part of the act in for use elsewhere in the proceedings – this is not cheating, it is being resourceful! Where you cannot fake it is with pantomime exchanges of the 'oh no it isn't' variety. In

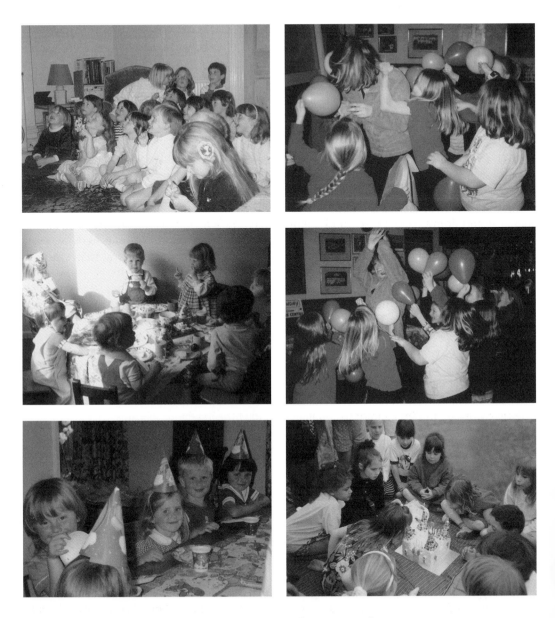

When shooting large groups, aim to capture a specific activity taking place, be it watching the entertainment, stuffing their faces or bashing the host with a bunch of balloons.

these cases, feel free to swing back and forth between subjects.

Present opening is fun, and it is great to see the look of delight on children's faces as they dig for treasure in boxes and wrapping paper. Go for close-ups on the lucky child's face as each present is revealed, but also try to single out the boy or girl that brought each one – almost as a way of saying 'thanks'. Party games are normally played to music, so keep the camera rolling so as to avoid a choppy soundtrack when it comes to the edit. Hunt the most entertaining reactions and most enthusiastic efforts, all the while being sure to keep the camera low, at child height. Are prizes awarded to winners of each game? If so, make a point of catching the winners' moments of glory (and the grumpy reactions of the losers).

Cakes and candles are an essential part of any birthday video, so be sure to get a good vantage point to shoot the emergence of the cake, lighting of candles and all the huffing and puffing that follows. Lights often go out for candle-blowing, so you are left with the choice of either working in dim conditions, knowing that the finished footage will suffer heavy grain and muddy detail, or fix a small soft light to the camcorder, which will flatten the picture aesthetically and kill some of the atmosphere, but will ultimately give you a picture to work with. The guests' rendition of 'Happy Birthday' should also be captured in its entirety. Incidentally, the song has a second verse that few people know about. And fewer people still are aware of the fact that it's still under copyright and subject to licensing fees for video productions (professional video makers should consult Warner Chappell Music). It's also guaranteed to make very young children cry. Just so you know.

It is up to you where you will decide to leave the video. It might be appropriate to leave the party on a high, with the music and games in full swing. If, on the other hand, you are committed to see the day to its end, keep shooting and capture the staggered departure of guests, leaving an empty (and probably very messy) venue. You might also want to shoot the cleaning-up process – especially as this means you can't also hold the mop and bucket yourself!

PROFESSIONAL EVENT VIDEOS – THE WEDDING

There seems to be a common belief among aspiring video professionals that a good and easy living can be made from wedding video production. I have met many newcomers to video, all ready to pack in their day jobs, wave goodbye to the boss and go it alone as wedding video makers, raking in tons of money, only working weekends and living the high life. It is true that wedding videos are expensive things to commission, but they are far from being easy money. In fact, I know of several experienced broadcast video makers who quickly decided that wedding videos just aren't worth the hassle.

Working as a one-person team is an immensely stressful and logistical nightmare. And there is also added pressure in the realization that you don't get a second chance at anything. If you miss a shot, it is gone and can't be redone. Similarly, if your sound is bad, there is no option for re-shoots. And as for a light workload, remember that you need to edit this movie as well as shoot it, and with the average wedding video running to more than two or three hours, that's an awful lot of work. Despite all this, some freelancers do make weddings the staple part of their workload. But those are brave and noble souls: wedding videos should always be considered the 'extreme sport' of video production, so don't venture in unprepared and you do so at your own risk!

Unlike home movies made for your own enjoyment, video made for hire must be made

to the highest quality you can afford. Some wedding video makers splash out massive sums of money on shoulder-mounted professional camcorders with interchangeable lenses, and while they look the part (impressing clients is a valid concern) and deliver first-rate image quality, some careful consideration must go into the pros and cons of investing in such machines. It is unwise to spend tens of thousands of pounds on equipment before you've earned your first penny.

That said, your choice of camcorders should be limited to 3CCD models. There are some very affordable machines out there, and it is always worthwhile checking internet auction sites such as eBay for second-hand machines. Visit manufacturers' websites and read up on their specifications. Look for models that perform well in low light: wedding receptions can often be quite dim and dingy. A good optical zoom is another

bonus, as you might not always have access to the best vantage points for ceremonies and speeches. Look for a good image stabilizer (the camera will regularly be mounted on and removed from a tripod) and choose a machine that can easily be toggled between manual and automatic controls – and one that is comfortable to use both ways.

Once you have found the perfect camcorder, count your pennies and buy two or three of them! This is a serious comment: your task as video maker will be made easier with the benefit of coverage from a second camcorder, and things will be improved further if a third is running. Knowing that action is covered in wide shots allows you more freedom in shooting close-ups and reactions – all of which will make for a smoother edit and a more professional-looking movie. If you can't afford two or three camcorders exactly the same, look at budget versions of your ideal model. The idea is to ensure that your back-up cameras

ABOVE: At least one additional camcorder makes a huge difference to your stress levels when trying to cover live events such as weddings!

RIGHT: Well-positioned microphones are a must, too. One or more placed near the subjects (or next to speakers if a PA system is in use) will help you collect clean, usable sound.

ABOVE: Wheels fitted to the bottom of a tripod make it easy to readjust your position with a simple, smooth glide.

RIGHT: FireStore drives such as the one perched atop this camcorder allow long recordings to be made without stopping to change tapes. They also plug directly into computers for immediate editing of the footage.

deliver footage with the same basic tonal qualities as your main camcorder. Stay with 3CCD camcorders and – if possible – stay with the same manufacturer, as each make of camcorder takes its own approach to colour reproduction.

A back-up camcorder is equally as important if there is more than one operator on the crew: if you have two camera operators, run three cameras. This is a busy day, and when camera operators are busy chasing killer shots, it is helpful if at least one camcorder is static and all-seeing. On the three-camera, two-person shoot featured here, one camera was operated on a tripod with wheels near the front of the cathedral, another was left wide and static – with no operator – at the front, and a third, at the back, was placed on a very high stand, with a remote-control head, allowing it to be panned and tilted. There was also a second controller plugged into this camcorder's Lanc socket to start and stop recording as well as to operate the zoom.

Monitoring with the camcorder's LCD panel is difficult at that height, so a video feed was channelled out of the camera to a small pocket TV set.

You are expected to be as discreet as possible, so while hand-held microphones might be fine for speeches later in the day, they are no good for the ceremony – and standing next to the bride and groom with a microphone as they take their vows is a no-no. As with most things, the camcorder's on-board microphone is wholly inappropriate for this kind of task. Good directional shotgun microphones are the only way to go, and make sure that there is sound recorded to all camcorders – part of the wedding shoot survival plan is to ensure that you have a back-up for everything! If you are well prepared and committed to spending some time on the edit, a neat supplement to shotguns is a cheap tie-clip mic attached to the groom's lapel, and a and personal minidisc recorder slipped in his pocket. With the recorder set to mono, a

74-minute disc will accommodate around two and a half hours of sound. Keep the same approach in mind when recording speeches, but remember to have enough recorders (and enough battery power!). Larger venues such as cathedrals may have a PA system set up, feeding sound to speakers positioned along the side walls. If this is the case, setting up a microphone next to a speaker could solve a lot of problems – but check in advance that the speakers will actually be used for the ceremony.

Much of the shoot will keep you in one place for long periods, whether it is recording the ceremony or the speeches, so a good tripod is essential. It must be solid, but also manageable when you are carrying it from place to place. Adding wheels to the base will allow you to reposition if necessary, without ruining an otherwise good shot by lifting and jerking. Wheels on the reception's dance floor will allow you to circle the bride and groom toward the end of the night.

Ask your client who is actually organizing the wedding. Their wedding plans are your script and will allow you to make lots of time-saving decisions well in advance of the wedding day itself. Scout venues and attend the rehearsal if there is one. Identify the best vantage points for cameras at each stage of the proceedings, and familiarize yourself with the quickest routes from one to the other. Talk to the venues' managers too, and check to see if any of the places you want to shoot from are inaccessible, sacred or dangerous. In the case featured here, the organ balcony was dangerous and closed for repairs, preventing us from getting a very high-angle wide shot down the centre of the aisle. The areas of the cathedral behind the priest (from which we would have got great shots of the bride and groom's faces) were also off-limits to us, being a sacred area of the building. Things can turn to panic if you only discover these limitations on the day of the shoot and are not prepared with a back-up plan.

Some venues – particularly large churches and cathedrals – will charge extra money for the right to record their choir on a wedding video. That is their right and there's no way around it if they do. Find out if this is to be the case and check to see who is expected to foot the bill, you or your client.

Keep an eye on the direction of the sun at the time of day that the ceremony will take place. Don't decide on a camera position that will put the sun directly behind the bride and groom! Knowing these things in advance will prevent untold hassles on the day.

Another thing you need to know in advance is the essential A-list cast for this movie. The bride and groom might be flying old Aunt Delia over from Australia just for the event, and they will want to see her on the video. Don't count on them telling you that unless you ask, though. And even when you have a mental list of must-have names, knowing people when you see them is another matter entirely. So aim to shoot everyone. Recording guest arrivals is one good approach for making sure that nobody gets missed. Similarly, asking people to deliver their best wishes to the happy couple on camera gives you extra coverage.

Know in advance how long the ceremony is likely to last. Anglican and registry office weddings are usually under an hour and can fit comfortably on a single MiniDV tape. Catholic and Indian weddings can be longer, though, and if you need to change tapes, it is essential that you are able to do so without disturbing the ceremony itself or missing any crucial moments. Working with multiple cameras allows you to stagger tape changes, but remember that some camcorders might be unattended and inaccessible mid-ceremony. Shooting in Long Play mode isn't an ideal solution as LP recordings are more prone to tape faults than Short Play recordings.

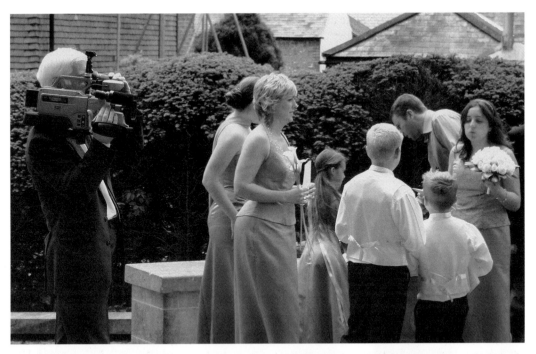

Shooting arrivals add to atmosphere and give a good lead-in for the main event. They're also a fantastic opportunity to get as many friends and family members on tape as possible, so nobody complains later that you have missed Auntie Sheila.

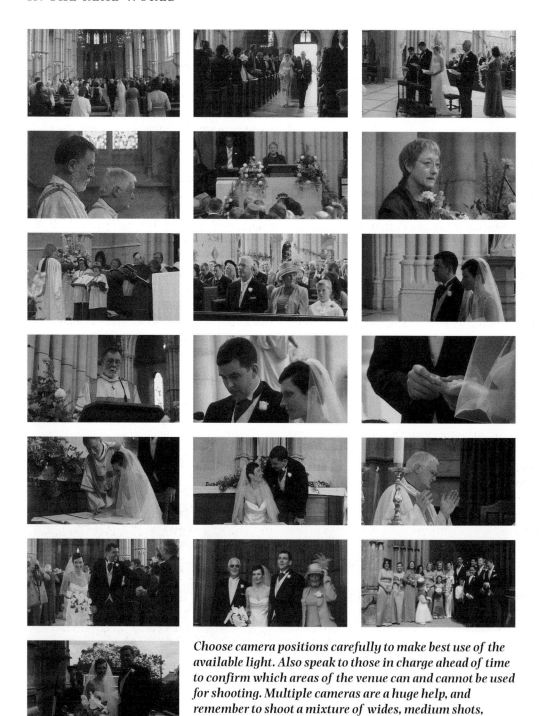

Choose camera positions carefully to make best use of the available light. Also speak to those in charge ahead of time to confirm which areas of the venue can and cannot be used for shooting. Multiple cameras are a huge help, and remember to shoot a mixture of wides, medium shots, close-ups and cutaways!

FireStore hard drives are a good, workable solution: the basic 40GB model can accommodate over three hours of DV footage and can later be connected directly to a computer, allowing footage to be edited immediately.

Secondary camcorders, back-up sound and lots of spare batteries are just part of the wedding video survival plan. The well-prepared wedding video maker should be prepared for poor lighting at the reception. Small LED lamps that sit on the camcorder's shoe attachment might flatten the image and kill the atmosphere, but at least they will allow the subjects to be seen.

Even though the wedding and reception represent a very long day, you can't afford to sit idle for a moment. Even when the main events aren't in full swing, you should be recording guests arriving, and making a big deal of shooting footage of the ushers and brides-maids. All this candid work can be done hand-held, and largely in automatic mode. Vary the shots, though, and get as many close-ups and cutaways as you can.

Being out front with the guests keeps you in the right place for the bride's arrival, and then it is full steam ahead through the wedding. Be more conservative with the camera at this point. Keep camera movement to a minimum and focus on the bride, the groom and whoever is performing the ceremony. If there are one or two fixed camcorders collecting static wide shots, you can vary close-ups and medium shots on the main players, and swing over to the guests during hymns and prayers, confident that the other camcorders are giving you adequate back-up for the edit. Keep focus and exposure on manual to prevent unwanted shifts during the proceedings. Camerawork can be switched back to hand-held and automatic for the signing of the register and dispersal of the guests. Don't wait to be offered a place to

shoot all this from: get in there fast and get the best shots you can.

Once the ceremony is over, catch the couple's exit and record some of the wedding photography before high-tailing it to the reception venue – ideally, ahead of the wedding party so that you can catch the main players arrive. Shooting guests being welcomed to the reception gets you more coverage of family and friends that might turn out to be essential for the final edit. At this point, it is important to know what order events will take in the reception. Will the guests be fed before speeches, or will the speeches be delivered first?

As the last of the guests are getting settled in the reception venue, race around to collect essential cutaway details such as the cake, decorations, and the collection of unopened wedding presents. If there is a good atmosphere brewing, collect candid shots of the people too, and pester more guests for dedications to the bride and groom if you can stomach it. Make sure microphones are set up

Shooting the arrival of guests at the reception provides another good lead-in to the movie's next episode, and reduces your chances of missing an important relative.

101

*Taking candid shots of people
at the reception is a good way
of collecting filler material
and adds to the atmosphere
and sense of enjoyment.*

in plenty of time for speeches, too: in the case
featured here, a couple of shotgun mics were
fixed to the top table and a hand-held mic was
also provided for anyone who wanted it. If the
top table is against a window, try to draw the
curtains in advance to avoid excessive back-
lighting. If that isn't possible, find backlight
compensation on the camcorder and make
sure to expose for the speakers rather than
the window. If you have the benefit of two
cameras, swing one round to the audience at
opportune moments to catch guests'
reactions during speeches.

*Fixing a number of good microphones to
the table where speeches are to take place is
a good approach for discreet recording
of first-rate sound.*

Speeches are easier to shoot comfortably when you have more than one camera running. Regardless, try to get a good mix of wides, close-ups and reaction shots.

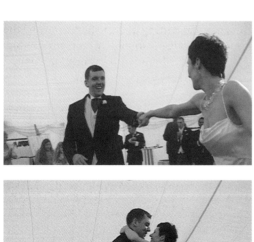

The first dance with the bride and groom is an essential part of your day, and can make an appropriate end to the video if you don't want to stay longer into the night.

You are unlikely to be offered dinner, so bring your own packed lunch and eat it discreetly outside while the rest of the guests are tucking into dinner. Things will kick off quite quickly once dinner is over, though, so keep an ear out, or ask one of the friendly staff to let you know when you need to be back at your post. Traditional and symbolic moments such as cake cutting and the first dance of the bride and groom should be caught in big, showy detail. There is no excuse for missing such things – or at least none that your clients will accept.

The first dance with the bride and groom is pretty much the last of your real obligations for the night. Keep the camera rolling for the

Good, snappy shots of the following party in full swing are bound to please your client, provided that the night goes according to plan and everyone has a good time!

duration so as to have an unbroken recording of the audio, and vary the shots, from wide shots showing both partners full-figure to close-ups, showing their facial expressions. If the floor is flat and solid, a simple set of tripod wheels will allow you to circle the couple for a sweeping romantic effect. Get the best shots you can, but be discreet and keep your distance – this is *their* moment after all! This dance could be the last event of your video. But if all goes as it should, the dance floor should start filling quite quickly. Try to collect shots of friends and family having a great time before you leave, making sure to drop the camera to child-height when shooting the kids dancing. The bride and groom, their parents and everyone else who has had a hand in organizing the day will appreciate being shown that everyone is enjoying themselves – and they are the people you rely on to recommend you to future clients.

MULTI-CAMERA SHOOTS – LIVE PERFORMANCE

From a video maker's point of view, there are two types of live performance: scripted and stage-managed productions such as plays and recitals, in which the actors and technical crew attempt to give the same performance each time; and the freer 'gig' such as a rock concert or improvisational comedy in which the performers do pretty much what they feel like on the night.

Regardless of the type of show, take care with your choice of camcorder for multi-camera projects. As already mentioned with regard to wedding videos, you are best advised to use two identical models, but if that is not a possibility, aim to get something similar from the same manufacturer. A combination of 3CCD Canon camcorders will give a better colour match between shots than a mix of, say, Canon and Sony machines. Also be aware that video from single CCD and 3CCD sources will give a poor match so they should not be used in combination if you can help it. Where you don't have a choice of camcorders, don't panic – you will be able to correct the colour later at the editing stage to make them match, but the process can take time, involve a lot of rendering, and will often require you to reduce colour saturation and lose much of the richness provided by 3CCD machines.

Big-budget shoots for broadcast are often shot and edited right there on the night. The camcorders feed a live signal to a vision mixer, where the editor monitors each camcorder's output, gives directions to each operator via radio headsets and cuts between each feed to create an immediate edit. Such shoots require a truckload of equipment (sometimes quite literally), and a lot of crewmembers as well as a large venue with sufficient space to set up the editing console – in some cases this might be set up in a specially adapted truck outside, but there is still an awful lot of organization and expense involved. The shoots detailed here aren't nearly so lavish. For a start, there is no live mixing console: all the editing will be done later. This requires more time in the schedule, but requires fewer crewmembers and gives the editor a little more control over matters, being able to spend more time over cutting decisions in a way that the live editor cannot do without the benefit of a time machine.

The controlled environment of a scripted play or recital allows you as a video maker more control if you are willing to invest some extra time and record multiple performances. In shooting live shows, two of your biggest limitations will be the number of cameras available and the number of camera operators – the number of camera viewpoints can be effectively increased by shooting more than one performance. Shooting a dress rehearsal with no audience present gives you the freedom to move about a theatre and collect

close-ups that you might not be able to get in a packed audience on show night. The problem with this plan, however, is that dress-rehearsal performances tend to be somewhat lacklustre compared with the actual show, where performers are running on adrenalin and responding to the presence of a live audience.

In a proscenium arch theatre (that is, a traditionally laid-out theatre), you face several challenges. First off, the stage itself tends to be quite high, so shooting from the front rows of seats will miss all the action bar that which takes place at the very front of the stage. You will be shooting right up those performers' noses and will have the lighting rig as the background, rather than the carefully crafted scenery that the show's designers and stage managers want seen in the finished video. Shooting from the sides often results in a partially obscured view of the stage, and for background you will have the wings in which performers are standing waiting for their cues. Ideally, all cameras should be fairly central in the auditorium, and at least one should be close enough to pick up close-ups while still being at about stage height.

On top of that, you might have the problem of theatre staff. On the helpful side there is the show's stage manager and the rest of the production team, who are probably the people that hired you in the first place and will do anything they can accommodate you and make the video a good one. On the other hand, there is the staff hired by the theatre itself. Some are reasonable people who will work with you providing you observe fire and safety regulations, but others can be jobsworths who seem intent on making life difficult just because they can. To avoid unnecessary confrontations and to demonstrate that you are not a cowboy, ensure that all trailing cables are properly hidden, and secured to the walls and floor with fabric gaffer tape: there should

be no opportunity for audience members to trip or fall over any of your gear. Secondly, make sure that none of your equipment obstructs the aisles or fire exits. Third, check that none of your kit prevents paying audience members from seeing the stage.

In the case shown here, the show in question was an annual revue from a local dance school. It was taking place in a large, 1,000-seater theatre over two or three nights, and we were booked for the Saturday to catch the matinee and evening performances. We encountered a theatre manager who informed us that the only places he would allow us to pitch tripods were at the very back of the stalls, on either side on the sound desk. From that distance, the camcorders' optical zooms were struggling to deliver even a medium shot of the performers.

After discussion with the producers, we reached a working solution: two rows of seats, approximately a third of the way back in the stalls had been set aside for special guests and the press. We took over two seats, mounting a camcorder on a tripod with a remote-controlled head that could be operated from the back of the auditorium. That operator had a full remote-control console, providing pan, tilt and zoom controls (the camcorder itself was set to automatic focus). There was also a video monitor at the back of the auditorium, displaying a live feed of everything that the unattended machine was seeing. That operator had a second camcorder with no remote control shooting just a static wide shot of the entire stage while another manned camcorder on the other side of the sound desk went in for medium shots, picking out groups of dancers and performers. With this three-camera set-up, we were able to collect wides, mediums and close-ups from a fairly central vantage point. The theatre manager still wasn't happy, of course, but admitted defeat when we were able to demonstrate that

107

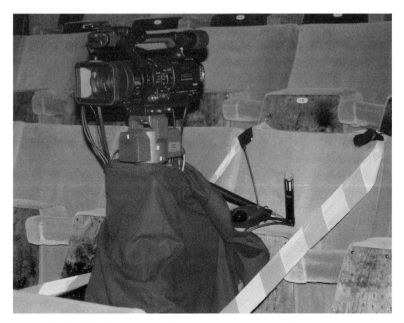

Our unattended camcorder, occupying a central seat and equipped with a remote-control head and a video output feeding a monitor at the back of the theatre.

The operator's remote-control panel is big and tactile and easy to find your way around in the dark!

A small TV monitor provides a live feed of the camcorder's output, and there is a small reading light allowing the operator to work effectively in the dark.

the unattended camera wouldn't obstruct anyone's view of the stage, and that we held the tickets for all seats occupied by the set-up.

The three camcorders in use could be switched between standard DV and high definition 1080i HDV formats. Because of the distances between the camcorders and stage, a decision was made to shoot HDV, even though the client only wanted a standard definition DVD at the end of the day. Doing this would allow us to crop into shots at the editing stage to achieve a tighter composition without overly compromising the quality of the final standard-definition movie. On paper, you can crop in to a quarter of the original frame without losing definition, but it is best to keep an eye on each case and judge things subjectively as you go.

If you have been able to get hold of a script or to attend rehearsals in advance, then you are at a great advantage as you know what the most dramatic moments are and will have a fair idea of the main cues, entrances and exits for each scene. If you are well prepared, your coverage can be well planned, making sure your camera is exactly where it should be at key moments. You will know which performers need to be followed at all times, and you will be prepared for any surprises. If it helps, each operator can keep a dim lamp and an annotated script handy so as to follow the play and make sure to catch important cues.

Treat dramas as you would a movie: break shots into wide, medium and close-up shots, moving in tight on actors at the most emotive scenes and pulling out wider for more physical action or to show off impressive scenery. If you have sufficient cameras, one can cover the whole stage, allowing others to follow actors for action and reaction.

Dance should be handled differently. Dancers are often concerned with the full figure, so big close-ups and detailed cutaways aren't really appropriate. In fact, in the case of

Microphones positioned behind the unattended camcorder allowed us to effectively record 'what the audience hears'.

tap dance, close-ups of feet are potentially far more relevant than faces. Your problems arise when working with dancers on a very large stage. In order to capture the full width of the show, you will almost certainly also have lots of unnecessary detail at the top and bottom of the frame. The 16:9 widescreen aspect ratio is a help in this situation, but even then you will be amazed at how wide even the most modest stage can appear from the back of an auditorium. Moving in to frame dancers full-height will also necessitate framing out lots of the stage, and having to make decisions about which performers to show and which not to.

Things get even more problematic for school productions or dance school shows, as there are often lots of students, and each dance segment will seem to involve every last one of them. In this case, try where possible to identify smaller groups of dancers and concentrate on them. If everyone is going through the same steps, pick out one dancer

and concentrate on them. You will still be able to see other performers mirroring the same moves in the foreground and background, so the point will still be well made. If you are panning with dancers, remember to allow space ahead of them in the frame so they don't look like they are about to bump into the edge. Be aware of head height, too: dancers can have a tendency to jump.

For one-off freestyle performances such as rock concerts, you don't have the advantage of shooting more than one show. While a stage play can be shot twice with two cameras to obtain the effect of a four-camera shoot, you will need four camcorders running at once to get similar coverage of a one-off show. Also, without a script, you can't block things in advance, meaning that your camera operators will need to improvise. You can give them basic instructions, such as to concentrate on certain people, or to shoot only wides or medium shots, but at the end of the day, they will be on their own.

Improvisational comedy is generally a breeze, as performers are normally tied to their microphone stand. And when there is only one person on stage, you have no dilemmas over where to point the camera – although using one to catch audience reactions is a good idea, if only to prove that the act is, in fact, funny. Either way, such shoots are easily accomplished with two cameras and one operator – one camcorder on a tripod shooting wides of the stage, and another being used to catch close-ups and audience reactions.

Live music poses more of a challenge but can be a lot more fun. For punk concerts I simply tell my crew to shoot whatever interests them most and to hunt the strongest images they can get. As they are placed at different vantage points in the venue, I can be confident that no two shots will be the same, and the free hunting being done by each camera operator should keep things exciting.

For these shoots, I have an operator behind each camcorder – none of the cameras is left unattended on tripods. One single static angle among three or four very active hand-held views can look out of place. There is also the fact that tripods catch a lot of vibration, and very loud concerts will give an annoying earthquake effect if the camcorder is left on a tripod; the closer you get to the front speakers, the more pronounced that effect will be. Wooden tripods help to absorb some of the vibrations, but even they are no match for the loudest of hardcore punk bands. If you are not comfortable with everyone working hand-held, try kitting each operator out with a shoulder brace, spreading the weight of the camera to their shoulders and backs rather than having it all carried by the arms. Avoid hand-held Steadicams and similar stabilizers, as they just add weight and will become uncomfortable for shoots over long durations.

Regardless of what kind of performance is being shot, each camcorder should record the full show in its entirety without being paused or stopped. The reason for this is simple – each feed will be 'synced up' for editing later. Synching up different video feeds ensures that editors can cut between different angles of the same event, happening at the same time. It's a bit like synchronising sound to picture, so that they both gel seamlessly. It can also be a big hassle and should ideally only be done once per project. If there is just one unbroken video feed from each camera, they will only need synching up once. And on the subject of sync, it is a big help if somebody can give a synchronization cue for all cameras. There's no need for a clapperboard or any fancy gear – simply setting off a still camera's flash gun will do the trick, and give the editor a reference frame from which to work. If that isn't a possibility don't worry, as sync can be found in other ways, normally by locating common sounds on each feed's audio track.

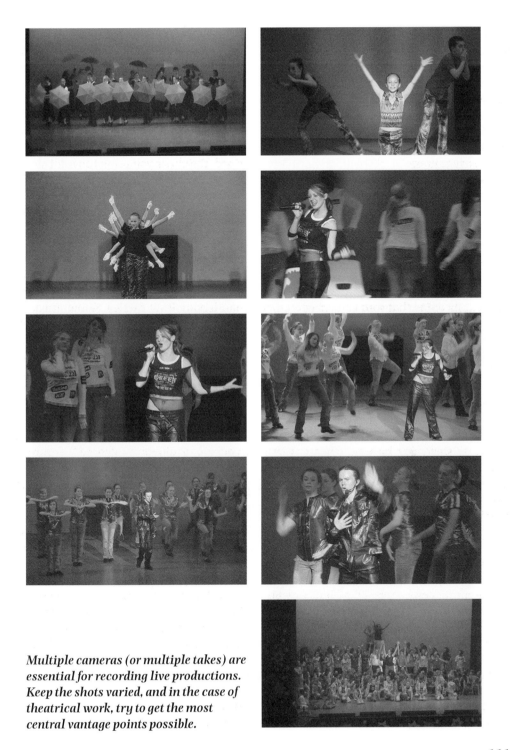

Multiple cameras (or multiple takes) are essential for recording live productions. Keep the shots varied, and in the case of theatrical work, try to get the most central vantage points possible.

If the show is set to last longer than an hour, make sure that each operator has spare tapes – and instruct each to change tapes at different times (55 minutes, 58 minutes and 60 minutes, for example) so that no more than one camcorder is out of action at any one time. If a camera is being left unattended on a tripod and can't be accessed mid-show for a tape change, set it up with a hard-drive recorder such as a FireStore drive, which accommodates far more than one hour of footage.

Sound recording can provide one of the biggest headaches when it comes to live shoots. For concerts and dance shows – and just about anything that happens in a big theatre – there should be a PA system with a sound desk. Taking a direct sound feed from it will give you clean audio, but unless that desk is just channelling pre-recorded music from CD, your recording is likely to sound a little dull and vocal-heavy compared with the full, solid sound the audience enjoyed on the night. Microphones in the auditorium can deliver a fuller sound, but without the crispness that the desk offers; mic recordings also pick up audience noise that can be annoying if people are chatting mid-performance, but absolutely invaluable for capturing applause and other useful reactions.

For very loud concerts, your microphones should be good ones that can withstand a lot of sound pressure. In turn, they should be fed through preamps to make sure that sound levels don't peak too high and ruin your recording. Some good results can be had by recording from the desk and from mics, and then mixing the two feeds at the editing stage. For more control, however, a multi-track hard-disk recorder is a great tool, allowing you to take multiple sound channels simultaneously. If the person behind the sound desk is friendly, you could ask for individual channels for things like vocals, drums, bass and guitar, as well as using the recorder to take the main mixed output and microphone inputs. Once recorded, these audio tracks can be copied directly to an editing system, and will already be in perfect sync with one another.

One last consideration to keep in mind is the need for a quick exit. Plays, recitals and concerts can end late at night, and the venue's

The mixing desk gives a clean feed of any sound that gets fed to a speaker, but the final mix might not accurately represent what the audience heard on the night.

Hard-drive-based multi-track recorders give immense versatility in recording several audio feeds – all of them perfectly synchronized with one another.

staff are often understandably keen to clear the building, lock up and get home. Have an organized plan for breaking down, packing up and getting out. Experience will show you the best approach for the kit you have and the types of venues in which you work, but at the most basic level knowing where the venue's stepladders are can prevent you wasting precious minutes waiting for a member of staff to point you in the right direction. Have torches handy so you can see behind equipment to unplug cables if the lighting is dim. Pocket knives are also useful for the quick release and disposal of gaffer tape. And on the subject of tapes, make sure that each cassette is clearly marked (they can possibly even be labelled in advance) and that they have had their tabs popped to prevent accidental erasure. Always try to leave the venue tidier than you found it so as to avoid any ugly confrontations, should you ever return.

DRAMA – CREATING WORLDS

Narrative drama shoots take in all the camera techniques already discussed. As everything is staged, every aspect of photography can be deliberated over to get just the right angle, good lighting, appropriate depth of field and smooth camera moves. How much is left to chance depends on the time you have and the way you work.

Drama shoots can be expensive and gruelling. They typically require more crewmembers than event videos or live shoots, and good actors and crewmembers generally cost money. It is true that many fledgling actors will sign up to a project just for the experience and to have something on their showreel, but the long hours and slow pace of drama shoots will quickly sour many people's attitude towards the job unless they have got the comfort of looking at it as paying work. Then there is the fact that experience shows on screen; or, to be more accurate, inexperience shows on screen – good, experienced actors give natural, believable performances.

Your costs don't stop there. You have to factor in costumes, sets, props, equipment and even food – remember that everyone needs to eat! Cast and crew respond well to confidence in the project's producer and director – not just in knowing what they want on screen but in having every small detail of the shoot in place so that everyone can get on with their jobs quickly and efficiently. And unless you are deliberately courting the unexpected and restricting yourself to real-world light and

These storyboards illustrate a hospital scene that isolates the main characters to an area dressed with a curtain, a bed and a machine that goes 'ping'. Provided that the decor and details are convincing, nobody will suspect that the actual shoot was done in a garage.

resources to achieve an extreme *cinéma-vérité* style, the job of preparing for a drama shoot is much bigger than with most other types of video production.

Careful notes should be taken of all costumes, set dressings and props required for each scene. Scenes should also be organized into 'story days', helping to ensure that continuity is strong across scenes as well as within them. If a character has already been seen in a car wearing a leather jacket and jeans, you don't want them arriving in a later scene (supposedly a few minutes later) wearing a formal suit. As scenes are normally shot out of sequence based on which actors and locations are available, such mistakes can happen quite easily if you aren't paying attention. There are systems of taking, filing and organizing notes like this, but the subject is far too big to spell out here. Anyone keen to make drama on the cheap is well advised to hunt out books dedicated to this subject alone, such as the *Guerilla Filmmaker's Handbook*, by Chris Jones and Genevieve Jolliffe, which features examples of real-world schedules, daily reports, call sheets, checklists, expense reports and many more forms and documents that don't inspire much excitement but which help keep a shoot moving smoothly and (hopefully) on time. On the basic level, however, have tramlined scripts, shot lists and storyboards ready in advance and talk everything through thoroughly with the key crew so they know exactly what is expected in terms of photography, sound and lighting.

New movie directors should remember that good crewmembers already know how to do their job. It is generally sufficient to tell them what you want, not how to achieve it. Much the same goes for actors: if they understand the character and context, they can give you a credible performance. Good actors will ask if they have any questions, and will also listen and respond well to your directions if you are looking for something different from them. But let them model the characters from the start, and then work with what they give you.

Be realistic with your schedule. Movie shoots involve long days, but people's performance diminishes as they become more tired. Don't expect your crew or cast to work round the clock without a break. Also be aware of the fact that sunlight is limited, so you are working against the clock in shooting exterior scenes. So as not to get caught out by fading light, begin shooting each exterior scene with the wide shots and then move in for the medium shots and finally the close-ups. If you run out of daylight, it is far easier cheating a close-up with additional lights than trying to simulate sunlight on a big, wide-angle establishing shot.

One technique that is widely used in low-budget drama (and some mainstream movies) is shooting 'day for night': the practice of filming night scenes in daylight so as not to suffer the expense and long hours of lighting a night-time scene. Interiors pose no problem, provided that the windows are properly blacked out and curtains closed, but working day for night in exterior locations can create more problems. The look and tone of video shot in sunlight can be altered and made more night-like in post production, but there is a lot you can do at the shooting stage to help things along. Some movie makers deliberately underexpose their scenes to make them gloomier. It is also useful to shoot as the sun is just rising or just setting, so as to avoid hard shadows and contrast. If there is good cloud cover to soften the light, so much the better. Above all, make sure to keep the sky out of shot at all times, as that will completely give the game away. A monastery massacre scene in John Carpenter's movie *Vampires* was shot day for night and managed to get away with it – although Carpenter's own commentary for the DVD is very critical and highly entertaining.

115

Lighting is one the main factors to slow down drama production. On the one hand, the extra time spent in setting up lighting can be invaluable – changing the quality of light to make a wet miserable day look like the height of summer, or turning a dark and dingy basement into an open-plan Mediterranean villa – but in many cases, you might get on perfectly will with found lighting (often known as practical lights) found on location – in other word, the natural light at the location. Video has a much greater sensitivity in low light than most film stocks, so look at the elements on a set that can produce light themselves. If necessary, bring in extra props such as free-standing or angle poise lamps to get light in the places where it is needed. So long as none of your light sources cast shadows of the crew in the frame, you can save yourself a lot of time and effort in lighting a scene, while creating a naturalistic image in which every light has a real, genuine source.

On a small DV drama, it is unlikely that you will have the budget to shoot in sets built on a studio's sound stage. But that doesn't mean that you cannot take the movie set mindset with you on location. The important thing to remember about sets is that they are just designed to look like specific environments. Applying that logic to a location shoot, we don't necessarily need to shoot a restaurant scene in a restaurant, or an office scene in an office, or a lunar landing scene on the moon. We just need to convince the audience that we are there. And, aside from NASA's continued difficulties in convincing sceptics about the moon landing, the job isn't really as difficult as it seems.

Audiences have a pretty good idea what restaurants, offices, hospital wards and other public settings look like, and that is a great help in that you don't need to show them every little detail for them to be convinced that you are there. Get the mood and trappings right, and you are free to get on with the story. Do your research, though: visit the places you want to recreate and take notes about the way they are lit, and the details that are visible. Also, regardless of the location, talk to those in charge and ask for permission to record audio wild tracks, as your re-creation will sound very different. Even if you end up re-creating a small part of the setting you want, viewers will believe in it if it looks and sounds authentic.

To further create a sense of reality outside the frame, think about sly lead-ins using close-up detail rather than wide establishing shots. A restaurant scene could start with the camera tracking with a dessert trolley, finally allowing it to leave the frame when we reach the table where our characters are seated. A scene set in a hospital ward might begin with a chart being filled in by a nurse, and slowly focus-pulling to the patient, or with a close-up of a machine that goes 'ping', then panning round to concerned relatives.

If you are confident with interior decoration and basic joinery, 'flats' constructed from wooden frames with stretched canvas can be decorated to resemble the walls of the location that you are trying to simulate. Doing so removes the need to paint or repaper your house just for the movie, and with a large-enough space, several flats can be assembled and dressed to create a makeshift set. Talk to the local council to see if it is possible to rent spaces such as the local school gym during holiday periods; if sets are designed in advance, you could shoot all the project's interiors in one place, saving time and providing a good degree of control, with the ability to remove walls in order to place the camera.

There is, of course, another way. Some movie makers – especially those used to working on tight budgets – find the answers they need by working almost exclusively in the real world. One fascinating example in

American cinema is cult movie maker Larry Cohen. In his movie, *God Told Me To*, a shootout scene set in New York's St Patrick's Day parade was actually shot in the parade itself. Key actors joined the march, and the crew posed as documentary film makers, going about collecting all the shots they needed for the scene with the exception of the gun being drawn and victims being shot, which were done later as close-ups (which didn't need a big crowd in the frame). During the 1970s and early 1980s, Cohen was also in the habit of having police officers played by real police officers. His explanation was that many officers were aspiring actors, keen to get into movies when they left the force; they also had their own costumes and already knew how to do things like handcuffing and restraining villains, so didn't need any special coaching.

DOCUMENTARY – BIAS IS THE BACKBONE

Documentary is a more popular movie genre now than it has been in almost a century. Far from being relegated to specialist TV channels, documentaries are now enjoying mainstream theatrical releases, and winning prestigious awards at festivals worldwide. Questions have been raised (largely from those that don't share the documentary makers' opinions) as to whether openly subjective works such as Michael Moore's *Fahrenheit 911* can truly be considered documentary. My assertion would be that this subjectivity is one of the key factors that makes documentary so exciting.

When making documentaries, you should remember that people find truth for themselves based on the information that is available to them and the way in which they interpret it. *Total* objectivity in any media production is practically impossible: choices have to be made right from the start regarding information that gets used or gets discarded.

Simply framing a shot imposes a bias on the movie, as the camera operator decides what the subject is going to be, and how much information will be included in the shot. Simply choosing camera height can impose an opinion on human subjects – do they look strong and dominant in the frame or weak and submissive?

Then there is the edit, which always applies a context: in presenting a chef cooking a chicken dinner, for example, do we start the scene with a nice, fresh chicken from the supermarket? Or do we begin with graphic images of the bird being slaughtered and gutted? Also, the way in which images, sequences and interviews are brought together helps to establish connections between subjects that viewers might not otherwise make on their own. Even though production takes place in the real world, with characters that really exist and events that really happen, there is still a story being told – and every story needs a good storyteller. Documentary makers don't just point their cameras on a subject and see what happens. Even with the limited budgets involved, they need some sense of a script, story and schedule, as crewmembers can still cost a lot of money, and need to know when to clock in and clock out.

In the case of *Fahrenheit 911*, Moore already knew his story, as it had already been mapped out for him in newspapers and broadcast news worldwide. Most of the movie's production time was spent picking out existing newsreels that best told that story from the author's perspective. Additional material shot for the project was largely done to illustrate points and emphasize conclusions that had already been made with stock footage from news channels.

Similarly, Morgan Spurlock might not have known exactly how an intensive diet of junk food would affect him before making *Super Size*

117

Me, but it is almost certain he knew it wouldn't make pleasant viewing. Without an idea of what the documentary's story is going to be, you are unlikely to get funding or interest from investors, distributors or broadcasters. The good news is that documentary budgets are so modest (compared with those of dramas) that once funding has been secured, interference from investors is generally minimal, all of which helps to ensure that it ends up with one singular, clear voice and perspective. Even if you are not chasing outside funding and are shooting small-scale documentary for yourself, make sure you start off knowing what the movie is going to be, what its subject and focus is, and how you plan to approach it.

Just as fictional drama productions differ greatly from one another in style and approach, so there is no one definitive 'documentary' look. Productions can be controlled and made with high production values and the full cooperation of the subjects, or they can be budget-conscious cheapies, or they can be daring investigative pieces, shot on the sly, with reluctant subjects. No matter what the approach, it is easy to keep the camcorders rolling non-stop. And although videotape can be quite inexpensive, hours on hours of footage presents massive headaches when the time comes to make sense of it all in the edit.

Even in a controlled environment and with a cooperative subject, it is rare that you will have the opportunity to set and adjust lighting for each shot. Interviews can be neatly lit with a key, fill and backlight, but in most cases it is more likely that you will be limited to a couple of lamps to ensure good exposure and create some sort of mood. Good camcorders handle relatively dim lighting quite well, however, so you might find it easier and more effective to work only with practical lights. Working in documentary puts you at an advantage in that viewers won't expect epic production values.

Some thought and control is still advisable though. Always think about where the main light source is coming from: if you are shooting indoors, don't frame subjects up against a bright window for interviews (unless you want to present them in silhouette); working outdoors, keep an eye on the direction of the sun, and get a friend to wield a reflector just out of shot to provide fill light if needed.

Due to the spontaneous nature of documentary, preparing a useful storyboard in advance is nigh-on impossible, regardless of whether you are working with your subject or chasing them on the hoof. However, there are methods of covering events that will help to ensure that edited sequences are smooth and fluid. Where possible, run two camcorders; for a polished production, two similar cameras will be a bonus, but if that isn't possible, viewers are more likely to accept differences in image quality between shots than they would in a drama. Have one camera chasing safe, relatively static wide and medium shots while the second moves in for close-ups.

Judge each situation to see whether it can be managed with manual controls or whether you are safer running with autofocus or automatic exposure enabled – a lot too will depend on how easy your camcorders are to control manually. Two cameras are a blessing, and represent one of the massive advantages of

*OPPOSITE: **These frames were taken from a candid documentary video covering the intense security at the 2005 Labour Party conference in Brighton, and the way it affected campaigners and protesters. The footage includes establishing shots, cutaways and people-shots. Even though lightweight DV equipment makes it easy to run away if someone doesn't like you filming certain events, I don't advise you to do so when armed police are on the scene!***

digital video: the cost of shooting, processing and printing film makes two-camera shoots too expensive for many low-budget producers. A second camera provides freedom for the editor and a useful back-up if anything goes wrong with footage from the first.

Be sure to record lots of cutaways. Cutaways are especially useful if you are in the position of running only one camera, as they will help you to trim footage and remove dead moments without there being obvious jumps in the on-screen action. Wild tracks are handy, too. Those purists who criticize documentaries for being controlled, contrived or subjective will be mortified to learn that many documentary makers are in the habit of shooting multiple takes of key events, asking their subjects to repeat their actions or discussions once or twice to make sure that they are properly covered. In the edit suite,

these takes will be cut together and presented as one single event. It is sly, but it is not cheating any more than shooting 'noddies' or questions after an interview has finished.

Even though much of the documentary's story will be kicked into shape in the edit suite, it is important to know when the story will end, otherwise you could spend forever following your subject. Unlike dramas, where you are working to a script and storyboard, and know exactly what footage is needed to make a completed movie, documentary shoots can go on and on unless you are sure about where you want things to begin and end. And even if you are careful about not overshooting and bogging the editor down with hours and hours of footage to log, it is still likely that you will fill an awful lot of tapes. Careful note-taking and labelling will help keep things moving smoothly once the shoot itself is over.

Shooting for TV Versus the Web

How your movie will eventually be watched can have a great influence on the shooting styles you adopt. As with the choice of camcorder format, video compression becomes an important factor when movies are published. The fine details of video distribution are a subject for another book, but it is important to bear in mind that the more a video file is compressed, the more its quality suffers. Compression is normally at its highest when streaming video on the internet, as well as with many multimedia applications such as promotional CD-ROMs. Even DVD can suffer, if the project runs to three hours or more and it all has to be squeezed onto a single 4.7GB DVD disc!

If you know that your movie will eventually be compromised in any of these ways (and that this is probably the only way that audiences will

see your work), play it safe with your shooting techniques. Lock the camcorder onto a tripod, keeping camera movement to a minimum, and try to avoid background detail in your shots – keeping both these factors to a minimum will greatly improve the look of your video when it has been compressed to excessive degrees. To help things further, light each scene so as to avoid high contrast, and try to make most of the shots bold mediums and close-ups, maximizing the size of important details: ultra-wide, sprawling, artsy landscapes will probably look awful when streamed on the net.

On the other hand, if the project is being made for broadcast, public performance or for private viewing on a DVD with a sensible level of compression that favours quality more than file sizes, consider yourself free to do whatever you like. Be adventurous and have fun!

CORPORATE VIDEO – CURB YOUR WILD SIDE

Corporate videos can be a good source of work for the professional freelancer. The term 'corporate video' can have a wide number of meanings, though, so it is important to spend some time in consultation with clients, to ensure you know exactly what they want. To many clients, a corporate video is like an extended advert – something that makes a big deal of a company's brand and products, possibly giving a sense of corporate history and generally massaging collective egos. It is something that can be distributed on DVD at trade shows or used to bore journalists rigid at product launches while they wait for the free bar to open. On the other hand, corporate video can serve practical purposes, especially in staff training or for internal meetings and conferences, enabling managers and other decision-makers to see at first-hand what is happening in different divisions of the business.

In either case, your clients are likely to be rather protective of the way in which their products and corporate identity are presented. Much of your brief will centre around the look of the product, the type of voice used to present it, the music used, the 'feel' of the finished video – even down to the fine details such as hair colour, costume and the ethnicity of presenters and actors. It is very unlikely that any of your clients will give a thought to making the video entertaining, and suggestions to that effect might not be very well received. It is not that companies want to bore people – it is just that one person's comic genius is another person's cringe-inducing embarrassment. Making a conscious effort to entertain can fall flat on its face, and that is too big a risk for a company to attach its name to. At the end of the day, corporate clients are most likely to be concerned about whether you could clearly see their logo and product – and that goes some way to explaining why the majority of TV advertising is deadly dull wallpaper.

So the best approach for corporate video is to keep things as simple as possible. Don't be adventurous with lighting or camera angles. Light and frame subjects for clarity rather than for effect. Keep the pacing leisurely and don't try to excite viewers. If this is a product-related video, get lots of close-ups of the item itself, and organize your script, shot list and storyboard to ensure that the video is about the product, not about the people presenting it. In a training video, close-ups of the job being done are far more valuable that talking heads. But while fun should be kept out of the proceedings as much as possible, it is important to make each shot technically polished. Framing and camera moves should be confident – not hunting for focus and reframing mid-shot – and sound clarity should be flawless. The actual picture quality should be excellent, too, which almost certainly requires a good 3CCD camcorder and a set of lamps for indoor shoots to keep gain to a minimum.

In terms of shooting technique, corporate videos demand the same level of measured control as drama productions and, as with dramas, it is a good idea to shoot several takes of each shot to be absolutely sure you have the best material possible. Plenty of coverage, alternate angles and cutaways are important, too, as the editor's job will be to keep the movie as lean as possible – and that will involve cutting out a lot of the material you've slaved over!

7 WHAT NOW?

Shooting video is only one part of the video-making process but, as we have seen, it is the stage where everything has to be right. Any decisions you make at editing and publishing stages can be undone or changed with the click of a mouse, but if the footage isn't good from the outset, your options for change and creative decision making will be badly limited. But it is also true that your movie is unlikely to fully engage the viewer or deliver the punch that you want from it without some careful and creative editing. To the newcomer, discarding footage is a painful process, but establishing a good pace and flow of ideas is crucial. I am sure that you have seen more movies that are too long than too short!

It is somewhat ironic that, in signing off this book, I should be encouraging you to look forward to the next step, clear in the understanding that your work is only part-way to completion. Depending on how you approach video production, the process of scripting and structuring the work may still lie ahead. Video editing is a huge subject in itself, though, and almost certainly one for a separate book.

In the meantime, keep an eye on the internet. There are lots of good resource sites and message boards populated by genuinely helpful individuals. It is possible to get a good grasp on the editing process just by haunting, reading and asking questions. As video editing makes further inroads into the main-stream computing market, so mainstream computing magazines are taking the subject more seriously, covering new products and techniques in reviews and tutorials. Some pieces are good but some are very weak, so make sure to cross-reference everything you read in magazines with real-world comments from actual users, either in general video-editing haunts or support forums for specific products. Or, of course, you could just look for my name on the byline! Seriously though, feel free to check in at my website at www.pcwells.com – it is more than self-promotion (although I do enjoy self-promotion!). I will be keeping it updated with links to useful resources, websites and message boards to help you up the learning curve!

GLOSSARY

Aperture
The opening in a camcorder's lens that allows light to pass through. The larger the aperture, the more light can enter in a given time, and the brighter the resulting picture will be.

Autofocus
Automated mechanical control over a camcorder's focus.

Bit
The smallest possible unit of digital information. Often referred to as One or Zero, Yes or No.

Byte
A group of eight bits recognized as a single unit of information, such as a number or letter of the alphabet.

CCD
Charge Coupled Device. The sensor that collects incoming light and converts it into an electronic signal.

Chromakey
A method of superimposing one video clip on another by identifying a specific colour as transparent. This colour is often green or blue, these being absent in normal skin tones.

Codec
Compressor/Decompressor. Information allowing video data to be compressed for storage and streaming and then decompressed for playback. A codec is the reference key with which players attempt to replace information that was discarded during compression.

Compact VHS (VHS-C)
VHS tape stored in a small cassette, allowing for a smaller size of VHS camcorder.

Component
A high-quality method of feeding analogue video. The signal is divided into three parts: sometimes red, green and blue, but more often a YUV colour space, where 'Y' is the brightness channel, and U and V are both colour channels.

Compositing
The combination of two or more video clips, graphics or titles in a single frame.

Compression
Reduction of data sizes by indexing and discarding information.

Crane
A long balanced arm used to lift cameras to extreme heights.

Crash zoom
Zooming in or out for effect during a shot. Many videographers use the zoom control to alter focal length between shots, believing the crash zoom to be too 'tacky'. Others find it useful and fun, and thoroughly embrace its tackiness.

Data rate
The amount of digital information that is read or written in a specific period of time, often measured in megabytes-per-second or megabits per second.

Depth of field
Range of distance from the lens in which subjects are in focus.

Digital8
DV video signal recorded to a Hi8 cassette.

Digital zoom
Electronic cropping and enlargement of an image after it has been processed by the CCD, to allow a higher level of magnification than is possible through the

lens alone. Digital zooms result in a very noticeable reduction in picture quality. Switch them off and forget about them!

Dolly
Wheeled platform or other support for a camera that allows it to roll smoothly on tracks or even floors.

DV
Digital Video. The term should specifically apply to the DV compression format used by MiniDV, DVCAM and Digital8 camcorders, as well as the majority of consumer-level editing systems. Also applies to a large-format cassette version of MiniDV.

DVCAM
Sony's 'pro' version of DV and MiniDV. The compression type, data rate and signal are the same as DV, but the tape runs faster through the machine, allocating more tape area to sound and picture and better defining the actual boundaries between video and sound information. DVCAM recordings are considered more reliable than ordinary DV, and less prone to faults and errors.

Exposure
The amount of light allowed in through the lens to feed a camera's CCD.

Fields
Alternating lines of image that make up video frames on standard cathode ray tube TV sets.

Filters
Effects applied to picture or sound to alter its overall tone or appearance. They can be applied to video digitally in post production or optically using accessories that fit in front of the camera's lens and treat incoming light before it reaches the CCD.

FireWire
Computer manufacturer Apple's name for IEEE1394 (*see* IEEE1394).

Fluorite lens
Specially treated lenses found on prosumer-level Canon camcorders. The fluorite treatment helps minimize distortion on excessive optical zooms.

Focus pull
Shifting the focal point of an image during a single shot. The technique is used in drama to shift focus between actors in dialogue where the shot has a very narrow depth of field.

FPS
Frames per second.

Frame
An individual image from a video or film clip.

Gain
Amplification. 'Gain' often represents a form of artificial amplification, boosting sound levels or video information beyond their normal levels – increasing volume or brightening picture, but often also amplifying mechanical noise.

GOP
Group Of Pictures. Highly compressed video for DVD publishing use three types of frame: self-contained index frames (or 'I-frames') and incomplete bi-directional (B) and predictive (P) frames. A 'Group Of Pictures' is the collection of frames between one index frame and the next.

Hi8
Higher-quality 8mm analogue video tape format. Uses the same cassette housing as Video8 but delivers a superior image.

HD
High Definition.

HDD
Hard Disc Drive.

HDV
High Definition Video. Uses standard DV and MiniDV cassettes but records a high-definition video signal, compressed as MPEG-2. At the time of writing, there are two resolutions of HDV: 1080i and 720p.

i.Link
Sony's name for IEEE1394 (*see* IEEE1394).

IEEE1394
A serial interface allowing data transfer of up to 400Mbit/s (the newer 1394b standard runs faster at 800Mb/s). It is used for connecting external devices such as hard drives and disc burners to computers, and is also the common standard for transferring DV and HDV footage between computers and camcorders.

Image stabilizers
Optical, electronic or mechanical devices used to reduce the effect of camera shake on hand-held shoots.

Interlacing
Breaking down a solid image into alternating fields.

IPB frame structure
See GOP

Iris
The plates inside a camera's lens, which create an aperture and control its size.

Jib
A small arm for smoothly raising and lowering the position of a camcorder.

kHz
kiloHertz. Used in sound recording, it represents a thousand audio samples per second. DV video typically has sound recorded at 48kHz.

Killer shot
A jaw-dropping indispensable shot. The kind of shot that grabs the viewer's attention and makes the movie itself memorable.

Lanc
Control protocol used in Sony and Canon camcorders. Lanc provides control over focus, zoom and recording pause. It can also be used to completely reprogram the camcorder if you are feeling brave or silly enough!

Linear editing
Assembly of footage in a sequence, starting with the first clip and moving steadily to the end. This is the approach used when editing video by copying clips between two video recorders. If a corrections need to be made halfway through the edit, every cut from that point on will need to be redone.

MicroMV
Tiny tape format introduced by Sony. Cassettes and camcorders are much smaller than their MiniDV counterparts, and video compression is MPEG-2 based.

MiniDV
Compact consumer camcorder format introduced by Sony in 1995. At the time of writing, the format has become the standard for the consumer market, effectively putting an end to analogue camcorder manufacture. The format is only now seeing competition in the form of high definition HDV – which is recorded onto MiniDV cassettes!

Motion Vectors
Calculations allowing an element of picture to be moved across a video image rather than be recreated for every individual frame. Motion vectors are essential in creating predictive and bi-directional frames in MPEG compression (*see* GOP).

MP3
MPEG-1 Layer 3 – an audio layer created with MPEG compression methods. MP3 compression delivers sound quality similar to that of CD, but with a fraction of the data, making it quicker and easier to send, receive and share songs on the internet. This is a worry for big record labels who see free online music distribution as a loss of profits, but a massive bonus for small independent and unsigned bands who need exposure but are normally excluded from commercial radio.

MPEG
Motion Picture Experts Group.

MPEG-1
Video and audio compression used for multimedia files and VideoCD creation. MPEG-1 video is typically reduced in size to a quarter of the area of full standard-definition video. The compression uses an IPB-frame GOP structure and audio compression is the basis for 'MP3' compression – MP3 is an abbreviation of 'MPEG-1 Layer 3'.

MPEG-2
Video compression method used for delivery of media on DVD and digital television. As with MPEG-1, it normally uses a GOP frame structure, but frame sizes are typically much bigger, at full standard-definition resolution or bigger, to support high-definition formats.

MPEG-4
A compression standard currently used for sharing high-quality video material over the internet – legally and illegally. MPEG-4 is also expected to be used for the delivery of high-definition content in the near future.

NTSC
National Television Standards Committee. The TV standard used in the USA, Canada and Japan. NTSC video runs at 29.97fps and standard-definition DV footage has a resolution of 720×480 pixels.

Omnidirectional
Not directional. An omnidirectional microphone will receive sound from all directions equally well.

Optical zoom
Magnification done within the camcorder's lens, before light reaches the CCD.

PAL
Phase Alternation Line. The TV standard for the UK, mainland Europe, Australia and New Zealand. PAL video runs at 25fps and standard definition DV has a resolution of 720×576 pixels.

Pan
Moving the camcorder left and right around a fixed axis.

PCM (or Linear PCM)
Pulse-Code Modulation – the digital representation of analogue sound. The quality of PCM audio is determined by its sample size (measured in bits) and its sample rate (kHz). PCM audio is uncompressed sound, and files for DV and high-quality music projects tend to be quite big.

Pixel
The smallest component part of a digital image. Think of a digital photo or video frame as a mosaic, and a pixel would be the equivalent of one tile.

Preamp
A device that allows control of audio levels before sound reaches the recorder and – in some cases – compresses the incoming sound to fit a required dynamic range.

Program AE modes
Automated camcorder presets designed to help compensate for awkward shooting conditions, such as backlighting or bright, snowy environments.

Progressive scan
Presentation of video as single self-contained frames rather than alternating interlaced fields.

Prosumer
Professional consumer. Affordable equipment and software pitched at well-heeled amateurs and keen enthusiasts, but good enough to be used for some professional jobs

Rendering
The process in which an editing computer will recreate clips to which effects have been applied. Complex effects require a lot of work on the part of the computer, and can take a long time to render – especially in the case of colour-correction effects or other video filters applied to long clips or sequences.

Resolution
The number of pixels that make up a digital image or video frame.

Sampling
The breakdown of audio and visual information into small numerical values. The larger each sample is – and the more of them you have – the closer your recording will resemble the original sound or picture.

Shutter speed
The time allowed for light to enter a lens for each digital image or video frame.

(Super) Steadyshot
Sony's name for image stabilization. The branding can be used to refer to optical and electronic image stabilization.

Super VHS (SVHS)
A higher-quality version of VHS. The tape housing is the same as VHS, as is the tape itself (although typically of a higher standard). Video information is scanned diagonally on SVHS tape, however, enabling a larger area of tape to be used, and giving rise to better picture and sound quality than was possible with standard VHS.

S-Video
Analogue video transfer in which brightness and colour information are fed through different channels.

Tilt
Moving the camera up and down about a fixed axis.

Track
Moving the camera on tracks or wheels.

Unidirectional
One direction. A unidirectional microphone will pick out sounds only in the direction in which it is pointed.

VHS
Video Home System. Until very recently, VHS was the most popular home video-recording format in the world.

Video8
8mm video format housed in a small cassette. Once popular as a camcorder format.

White balance
Defining the nature of white for a camcorder so as to ensure accurate colour reproduction.

XLR
Audio connections used in professional recordings. XLR feeds are balanced and also provide phantom power to microphones when needed.

INDEX

180° line 57, 58
3CCD 24, 38, 43, 45, 53, 54, 96, 97, 106, 121
Action-safe 70
Analogue 7, 12, 13, 14, 16, 27, 28, 29, 81, 124, 125, 126
Anamorphic 38, 39
Aperture 29, 35, 45, 73, 82, 83, 123, 125
Aspect ratio 38, 40, 41, 109,
Audio levels 29, 35, 53, 112,
Autofocus 37, 41, 42, 45, 83, 118, 123

Backlight compensation 46, 102
Backlight 60, 61, 118, 126
Barn doors 53, 61, 62,
Batteries 24, 27, 29, 30, 33, 54, 89, 98, 101
Beta SP 16
Bidirectional frames 15
Boom 9, 33, 53, 57

Camcorder shape 22
Camera shake 25, 26, 65, 66, 76, 77, 124
Cases and bags 34
CCD 22–6, 45, 47, 48, 74, 77, 81, 106
CD-ROM 120
Childrens' parties 90–4
Chromakey 15,123
Cine film 7, 22
Close-up 55–8, 60, 68, 69, 71, 84–6, 90, 91, 93, 94, 96, 98, 100, 101, 103, 106, 107, 109, 110, 115–18, 120, 121
CMOS 24
Codec 14, 123
Colour sampling 14, 15
Colour temperature 37
Compact Flash 30
Component video 13, 14, 28, 123
Composite video 28
Compositing 15, 123
Compression 13, 14, 17–19, 21, 123–5
Continuity 57, 60, 85, 115
Corporate video 10, 11, 31, 62, 67, 71, 75, 76, 79, 83, 86, 121
Crane 62, 64, 65, 123

Cutaways 85, 86, 100, 101, 118, 120, 121
Cutting cues 86

Day-for-night 115
Depth of field 24, 25, 45, 46, 66, 70, 73–7, 82, 113, 123, 124
Diffuser 53, 54, 59, 61
Diffusion filter 83
Digital 7–18, 21, 22, 24–32, 38, 48, 52, 62, 66, 81, 82, 123–6
Digital television 9, 125
Digital zoom 25, 48, 123, 124
Digital8 16–18, 123, 124
Documentary 33, 37, 57, 74, 75, 84, 86, 117–20
Dolly 62, 63, 124
Drama 33, 36, 37, 44, 49, 57, 62, 67, 68, 71, 74–6, 78, 80, 84, 86, 87, 109, 113–17, 118, 120, 121, 124
DV 8, 12–20, 22, 25, 28, 32, 38, 48, 52, 62, 101, 109, 116, 118, 123–6
DVCAM 16–18, 124
DVD 10–13, 15, 16, 18, 19, 21–3, 28, 52, 76, 109, 115, 120, 121, 124, 125
DVD camcorder 18, 19, 23
DVD+R 18
DVD-Audio 13, 52
DVD-R 18
DVD-RAM 18
DV-input 28, 32
Editing 7–11, 13, 15–19, 21, 28, 29, 31, 32, 40, 55, 57, 64, 68, 70, 71, 73, 77, 81, 82, 84, 85, 87, 90, 93, 94, 96, 97, 101, 106, 109, 110, 112, 116–18, 120–2, 124–6
Electricity 27, 54
Electronic image stabilisation 22,25, 26, 65, 96, 124, 126
Event videos 21,37, 42, 68, 70, 71, 86, 90–106, 113
Exposure 27, 29, 35, 40, 43–7, 53, 76, 90, 101, 118, 124
Eyeline 57, 71, 77, 78

Fields 15, 17, 40, 41, 124, 126
Fill light 60, 61, 73, 118, 120
Film festivals 10, 19
Film transfer 40
Filter 35, 37, 47, 48, 74, 82-84, 89, 124, 126
FireWire 13, 28, 124
Flag 61, 62
Focal length 48, 73-76
Focus pull 9, 43, 74, 75, 82, 124
Frame rate 12, 17, 18, 21
Framing 55, 56, 70–3, 109, 117, 121
Fullscreen (4:3) 17, 22, 38, 40

Gaffer tape 53, 107, 113
Gel 53, 61, 79
GOP 15, 124, 125

Handheld shooting 22, 49, 101
Hard drive camcorder 21
Hard drives 11, 13, 21, 28, 101, 112–14
Hard light 58, 59
HDV 16, 19, 20, 24, 28, 41, 52, 109, 124, 125
Headphones 33, 53, 89
Headroom 70, 71
 Camera height 51, 77, 94, 97, 106, 117
Hi8 16, 17, 123, 124
High definition 16, 19, 28, 41, 109, 124
Holiday videos 10, 16, 47, 88–90

Interlaced video 15, 17, 19, 40, 41, 126
Intra frames (I-frames) 15, 124
IPB-frame structure 18, 124, 125
Iris – see aperture

Jib 62–5, 125
J-Lip 28

Key light 38, 60, 79

Lanc 28, 97, 125
Laserdisc 13, 15
LCD panel monitor 22, 26, 27, 29, 30, 43, 47, 51, 62, 97
Lens 7, 22, 25, 26, 31, 34, 38, 40, 41, 43,

45–8, 64–7, 73–7, 82, 83, 89, 96, 123–6
Lens adapter 49
Long play 98
Long shot 55, 56, 68, 71

Manual focus 28, 31, 43, 71
Medium shot 55, 56, 68, 71, 90, 100, 101, 107, 110, 115, 118
Megapixel CCD 22, 24, 26, 30
Memory cards 22, 28, 30
MemoryStick 30
MicroMV 18, 22, 125
Microphone 10, 27, 32, 33, 35, 36, 52-54, 57, 64, 66, 70, 89, 91, 96–8, 102, 109, 110, 112, 125, 126
Minidisc 97
MiniDV 7, 12-14, 16-19, 21, 25, 27, 28, 38, 40, 52, 81, 87, 89, 98, 123, 125
Mixing desk 54, 107, 112
Mono 52, 98
Motion blur 45–7, 49, 77
MPEG 15, 18, 125
MPEG audio 52
MPEG-1 52, 125
MPEG-2 18,19, 21, 124, 125
MPEG-4 125
Multi-camera shoots 52, 54, 85, 98, 100, 106, 111
MultiMediaCard 30
Multi-track sound recording 112, 113

Neutral density (ND) filters 35, 47, 82
NTSC 12, 14, 17, 22, 38, 40, 41, 125

Optical image stabilisation 25, 26
Optical zoom 25, 48, 96, 107, 124, 125
Overexposure 45, 46, 76

PAL 12, 14, 15, 17, 41, 125
Pan 28, 33, 36, 51, 52, 62, 71, 76, 93, 97, 107, 110, 110, 116, 126
PCM 52, 126

Perspective 70, 75, 76
Pixel 12, 14, 17, 19, 22, 24, 25, 38, 41, 42, 52, 125, 126
Plasma screen 19, 40, 41
Playback 12–14, 28–30, 38, 123
Point of view shot 86
Practical light 116, 118
Preamp 112, 126
Predictive frames (P-frames) 124, 125
Program AE modes 45, 46, 90, 126
Progressive scan 17, 19, 40, 41, 126

Rain cover 89
Reaction shot 84, 85, 93, 103
Reflection 79, 81–3
Reflector 33, 34, 60, 118
Remote control 66, 97, 107, 108
Rendering 82, 84, 106, 126
Resolution 12–14, 18, 19, 21, 22, 24, 25, 27, 30, 40, 41, 52, 124–6

Safety 34, 36, 51, 54, 107
Sample rate 52, 126
Sample size 52, 126
Script 36, 67–9, 86, 87, 91, 98, 106, 109, 110, 115, 117, 120–2
Scuba housing 90
SD Card 30
Shoe 27, 32, 34, 101
Shot list 68, 87, 115, 121
Shotgun microphone 33, 57, 97, 102
Shoulder brace 67, 110
Shutter speed 29, 31, 35, 40, 45–7, 77, 80, 82, 126
SmartMedia 30
Soft light 58, 59, 94
Sound recording 7, 9, 10, 12, 27, 33, 52, 53, 55, 57, 64, 94, 96–8, 102, 107, 112, 116, 121
Spun 59
Steadicam 6, 65–7, 74, 110
Stereo 12, 28, 52, 53, 64
Storyboard 6, 37, 58, 68, 69, 86, 87, 114, 115, 118, 120, 121

Streaming 10, 15, 120, 123
Strobe 47, 80, 81
Sunlight 26,29,38,47,58, 60, 80, 115
Surround sound 13, 52, 64
SVHS 8, 16, 126
S-video 13, 28, 126
Synchronisation 64, 80, 110, 112, 113

Technicolor 81
Texture 34, 58, 76, 81
Tie-clip microphone 33, 52, 53, 57, 97
Tilt 33, 36, 49, 51, 52, 62, 76, 97, 107, 126
Tracking 7, 62–6, 71, 75, 116, 124, 126
Tramlines 68, 115
Tripod 10, 28, 30, 33, 36, 49–51, 62, 63, 76, 89, 91, 96–8, 106, 107, 110, 112, 120
Tripod mount 30
Tungsten 37, 38

Underexposure 76
USB 28

VHS 9,11–13, 15, 16, 123, 126
Video light 27, 32–4 53, 61, 91
Video Standards 12
Video8 16, 17, 124, 126
VideoCD (VCD) 15
Viewfinder 22, 26, 27, 29, 51, 74, 89

Water 36, 37, 46, 54, 61, 77, 82, 89, 90
Wedding videos 6, 10, 69, 71, 83, 94–106
White balance 29, 37, 38, 126
Widescreen (16:9) 17, 22, 38–40, 109
Wild track 64, 90, 116, 120

XLR 33, 126

YUV 14, 28, 123

Zoom 7, 25, 28, 36, 43–5, 48, 49, 66, 74–6, 89, 97, 107, 123–5